IMAGES
of America

HAYS
THE 1930s

ON THE COVER: In 1931, two events combined to form one large celebration: Fort Hays Kansas State College celebrated its 30th anniversary with the vice president of the United States as the keynote speaker, and a state park, Frontier Park, was dedicated by the governor of Kansas. It was a sunny June day and the crowds were thick. (Courtesy of the Dorothy D. Richards Kansas Room; photograph by R. E. Ekey.)

IMAGES
of America

HAYS
THE 1930s

Mary Ann Thompson and
the Hays Public Library

ARCADIA
PUBLISHING

Published by Arcadia Publishing
Charleston SC, Chicago IL, Portsmouth NH, San Francisco CA

Printed in the United States of America

Library of Congress Control Number: 2010924227

For all general information contact Arcadia Publishing at:
Telephone 843-853-2070
Fax 843-853-0044
E-mail sales@arcadiapublishing.com
For customer service and orders:
Toll-Free 1-888-313-2665

Visit us on the Internet at www.arcadiapublishing.com

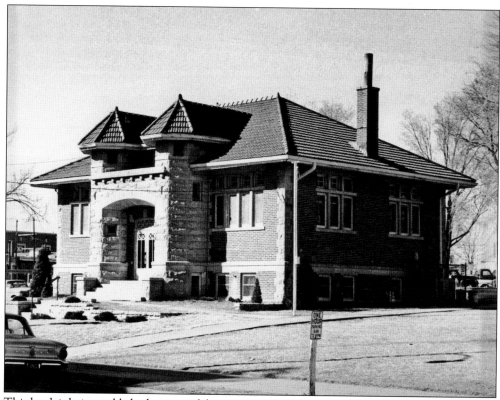

This book is being published as part of the centennial celebration of the Hays Public Library and is therefore dedicated to 100 years of library service, support, use, and participation by the citizens of Hays and Ellis County. Congratulations to the last 100 years of staff, members of the board, our Friends of the Library, and our Hays Public Library Trust. (Photograph by Pete Felten.)

CONTENTS

ACKNOWLEDGMENTS

The Hays Public Library has had a Kansas and local history collection since the 1950s. The Dorothy D. Richards Kansas Room includes, as part of that collection, a remarkable collection of historic photographs. While we have some early photographs of Hays, the majority of our current collection is from the 1930s. The collection of photographer R. E. Ekey was donated to the library in 1986 by his son, Jack Ekey, also a photographer, whose collection was donated at the same time. We are forever indebted to Jack Ekey for this donation and for the illustrated history of Hays it provides us.

The Ekey collection consists primarily of negatives, which we have had printed for the public to view. Local photographer Leon Staab has been instrumental in making it possible to have these negatives printed and available.

Thanks also go to everyone who helped check the accuracy of the captions and helped in the identification of some of the photographs. I also thank Ted Gerstle, Arcadia Publishing editor, for his immeasurable help with this book.

All of the photographs used for this work are from the Dorothy D. Richards Kansas Room photographic collection. Unless noted, all photographs used for this work are by R. E. Ekey.

The following are acronyms or shortened names for various publications used throughout the text:

Chicago Daily Tribune – CDT
Ellis County News – ECN
Hays Daily News – HDN
Kansas State Geologic Survey – KSGS
Reveille, Fort Hays Kansas State College – *Reveille*
St. Joseph's *Cadet Journal* – *Cadet Journal*
St. Joseph's *College Bulletin* – SJCB
State College Leader – *Leader*

INTRODUCTION

Hays, Kansas, was founded in October 1867 as the Union Pacific Railroad was built through the state on its way to Colorado. The town's location in the central part of the state, on the railroad and later major highways, ensured a certain commercial prosperity. While it has always been an agricultural area, the wheat fields would eventually also include oil wells. The original fort, built to protect settlers from the American Indians, would transform into a state college (ultimately university), an agricultural experiment station, and a state park. The citizens of Hays have been representative of a variety of people, starting with the railroad workers and soldiers who made up the town during those earliest years and including early settlers from the Eastern United States and the Germans from Russia who immigrated to the area in the late 1870s. Hays began as a frontier town of under 1,000 people at its first census and has steadily grown to its present size of 20,000. This growth had occasional spurts and was punctuated by periods of historical significance.

This book covers one of those periods: Hays in the 1930s. As a decade, the 1930s in Kansas had more to offer than one would perhaps first think. Yes, there was a national economic depression, and the dust bowl displaced many farmers to other occupations and other areas of the country. However, the world continued to spin, and in Hays that world included a population growth of 2,000 and an existence filled with great variety. That variety included special events such as anniversary celebrations, Easter egg hunts, and May Day fun. It included sporting events, both in the schools and in the town; concerts; dance events; plays; and Tom Mix. Education was important from grade school through college, and people worked to get through to better times, whether on the farm, in stores, or as part of the Civilian Conservation Corps (CCC).

Hays has always been involved with the arts, and during the Depression was no exception. Largely due to having a college in town, there were concerts, plays, and dance recitals every year as part of the school's curriculum, which were enjoyed by all, town and gown alike. The high schools also had many activities, and sometimes other groups would join in and put on a show as well. It seems that there was always some kind of concert or show to attend.

Fort Hays Kansas State College, now known as Fort Hays State University, was very active during this decade. The name changed from the Kansas State Teachers College to Fort Hays Kansas State College in 1931 to reflect the change in its curriculum from a teacher's college to a liberal arts college. Its enrollment increased from 653 in the fall of 1930 to 991 in the fall of 1939. Besides the college, there was a K–12 school located on campus, and in town there were two public elementary schools, a public junior high and high school, a Catholic elementary school, and two private Catholic high schools (one for boys and one for girls). The Hays Public Library was well on its way to becoming overcrowded with books and people. Education flourished throughout this decade.

During this time, Hays would celebrate two large anniversaries: the 70th anniversary of the founding of Hays and the 30th anniversary of the college, which was combined with the dedication of Frontier Park. The state convention of the Knights of Columbus took place in Hays in 1931,

as did the state convention of the Independent Order of Odd Fellows (IOOF). There were also several other special events during the 1930s that were fun and well attended.

Being involved and active seemed to be a natural part of the lifestyle during this period. There were sports teams from the college and high schools that one would find in any similar community. Hays, however, also had city teams for baseball and basketball that played neighboring towns. There was a boxing club for boys, a golf course near the historic fort, and the citizens were known to play an occasional game of polo. If one was not a participant, then he or she was no doubt a spectator. These sports were a vital part of the social activities of Hays.

If the people played hard, they worked harder. Even with the drought and wind, Hays was still an agricultural area, and farming was very important. In addition to agriculture, Hays had the good fortune to be a part of the oil industry that was booming in its early years. Because Hays was the population and commercial center of the area, there were many stores and businesses that operated all through the 1930s. Moreover, Hays was privileged to have several structures built with the help of the various federal programs at the time, such as the CCC and the Works Progress Administration (WPA).

When visiting Hays today, one sees the buildings from her past. The Chestnut Street Historic District located downtown is filled with the buildings present in the 1930s, and they are currently being revitalized and restored to their original look. One can easily recognize many of the present historic structures in these photographs of the past.

No portrait of any town would be complete without its people. Not necessarily the leaders of the community, but the men's and women's clubs, the boy scouts, and the church groups were the people who made Hays a community. These people and their activities represent a fascinating and heartening view of life in Hays.

Hays in the 1930s was an example of American resilience and resourcefulness. While the troubles of the rest of the country existed in the heartland, they did not interfere with everyday living. Life continued on and people adapted when necessary and made their lives as satisfying as they could. This photographic record of these times is positive, even energetic, in showing the upside to a depressed decade.

One

ARTS AND
ENTERTAINMENT

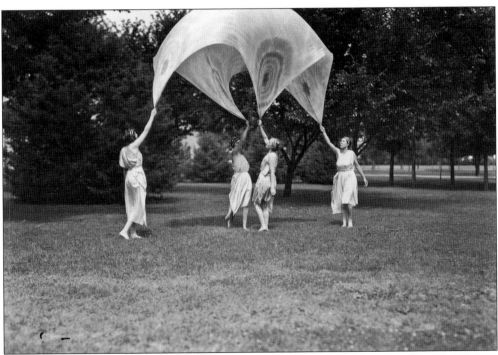

Elizabeth Barbour became the new instructor for women's physical education at Fort Hays Kansas State College (FHKSC) in January 1931. Her specialties were "dancing, including all its phases, and swimming," stated the January 22, 1931, issue of the *Leader*. Growing up in Chicago as the daughter of a senator, Barbour had many opportunities to see and experience dance, including a trip to Paris when she was 21. This summer class held in July 1931 exemplifies the modern dance of the time, reminiscent of Isadora Duncan.

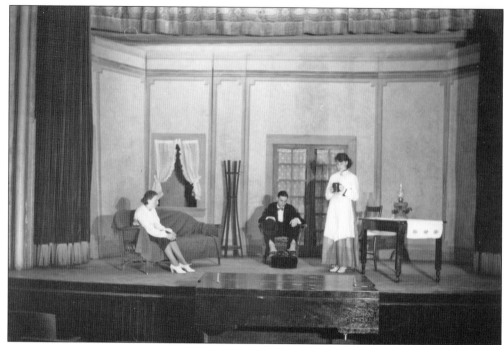

The William Picken Training School junior class presented two one-act comedies on April 11, 1935, in the college auditorium. *Getting Acquainted* (above) is the story of two sisters who have had the same hesitant suitor for 15 years. Pictured below is *Where's Elmer.* " 'Where's Elmer' is a snappy play with a cast made up entirely of boys. It deals with the activities of a small town fire department to help Mrs. Gibbs in detecting her husband's oncoming worldliness. Edwin Bunker plays the part of Elmer Gibbs, the errant little husband who has gone 'Mae West,' " stated the April 4, 1935, issue of the *Leader*.

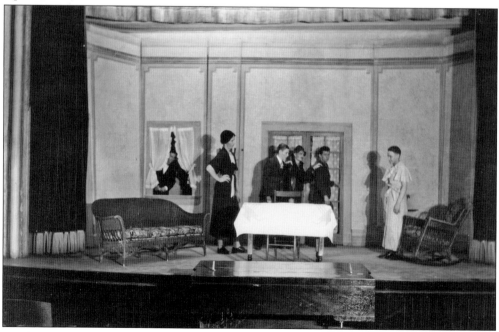

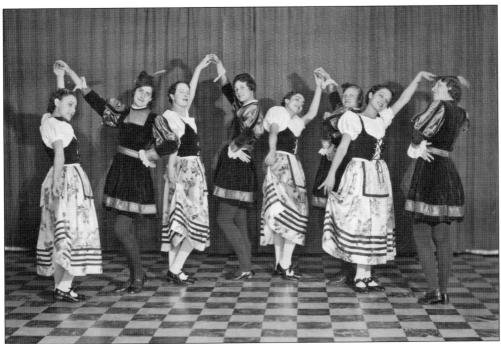

A new club was formed at FHKSC in 1931. It was called Orchesis (Greek for "to dance"), and it included advanced dance students who wanted an activity credit in interpretive dancing. There were tryouts each semester, ensuring the quality of dance from each member. These photographs show a performance from October 1934 where the group danced the fair scene in *Martha*. The 1935 *Reveille* reported, "Members of the group include Ruth Garlow, Helena O'Loughlin, Kathryn Parsons, Helen Francis Bice, Clara Nicholas, Nora King, Kathryn Reed, and Neola Gick."

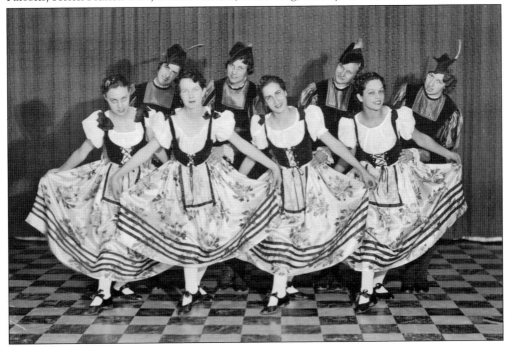

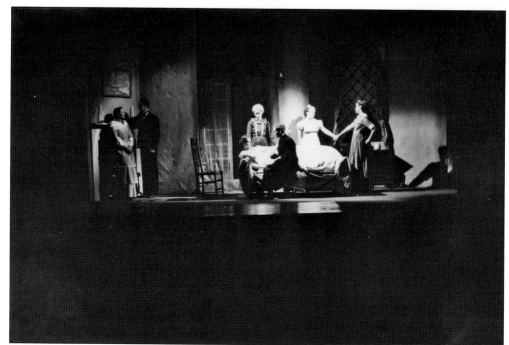

FHKSC had a drama group called The Little Theatre that performed plays both on campus and on the road at various area high schools. In February 1939, the play presented was *Little Women*. It opened on February 2 on campus and played on February 10 (pictured) at a neighboring high school. The February 2, 1939, issue of the *Leader* stated that the play "is an account of the sufferings and privations of a typical refined American family during and immediately after the Civil War. This period may well be compared to the period of economic depression of the past few years."

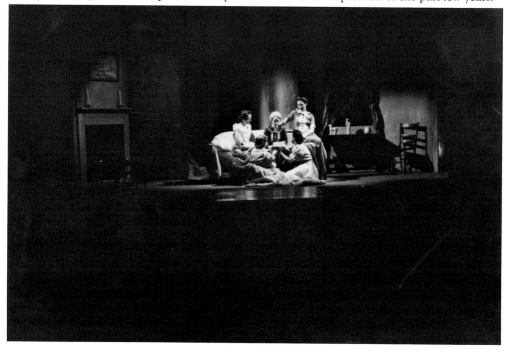

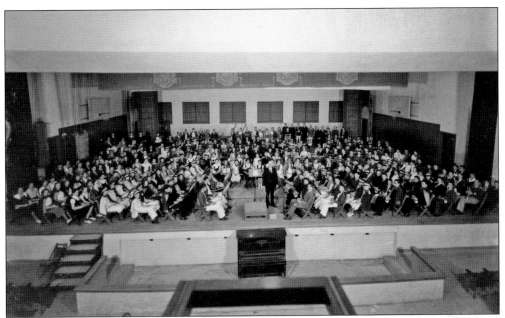

The Union Pacific League was comprised of high schools from towns along the Union Pacific Railroad, and they held a music competition each year. In 1936, the annual music festival included contestants from the towns of Wakeeney, Wilson, Russell, Ellis, Quinter, and Hays. The final combined concert took place April 6 at the St. Joseph's College Auditorium. The combined band contained 375 members from all seven schools.

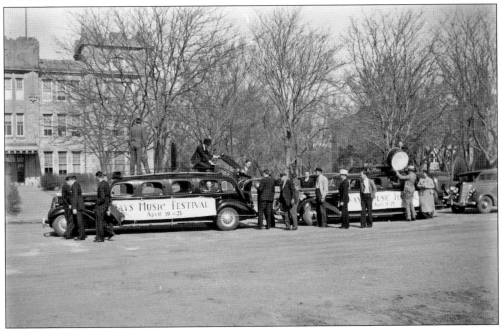

FHKSC held a music festival each spring throughout the decade. In order to promote this weeklong festival, a 20-piece band would set out on an advertising junket prior to the festival. Pictured here on March 20, 1936, the band and members of the Hays Chamber of Commerce are setting out for three days.

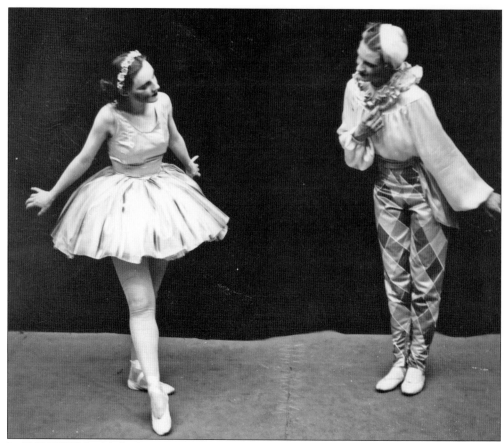

In 1937, FHKSC added a dance program to its annual music festival that took place the first week in May. The May 7 program, shown here, had three parts. The April 29, 1937, issue of the *Leader* reported that the first part featured the "Schubertiana Ballet; the second, an orchestral interlude; and the third, a character ballet, 'The Wonder Toy Shop.'" All of the music in the first part was by Schubert, and the costumes were all white and silver. The music in the third part was by various composers, and the costumes were very colorful. The choreography for the entire program was by Elizabeth Barbour, instructor for dance and physical education for women.

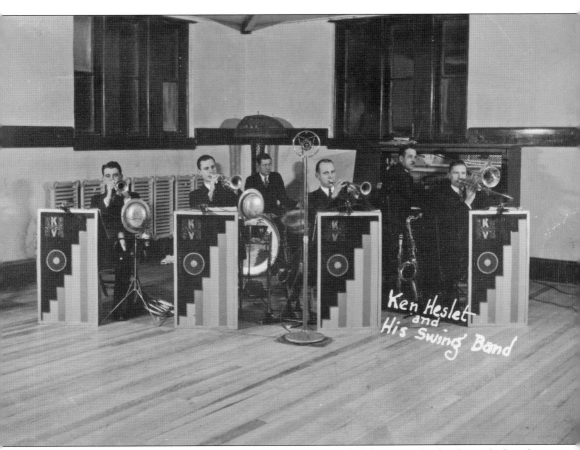

Ken Heslet
and
His Swing Band

The big band sounds of Ken "Sleepy" Heslet's orchestra provided the music for the dance (referred to as a varsity) that took place in the Woman's Building at 8:30 p.m. on Friday, November 20, 1936. "Admission is 35 cents for the men and ladies are admitted free," stated the November 19, 1936, issue of the *Leader*. Later remodeled and renamed Martin Allen Hall, the name "Woman's Building" referred not to its use, but to the fact that the dean of women had her office there. Dances and other nonacademic activities often took place in this building because it had a gymnasium.

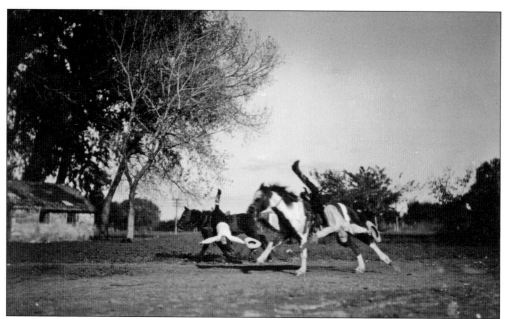

In 1930, Hays was the home of Graham's Western Riders, a stunt horseback-riding family of performers. Olson "Ole" Graham was the head of the group, with his daughter Lorraine, nine years old, as the headline performer. "She . . . will be remembered by thousands of persons who saw her do all manner of next to impossible stunts with her pony," reported the March 6, 1930, issue of the *ECN*. This group, originally from Salina, Kansas, performed for years at the Chicago International Horse Show. The December 7, 1939, issue of the *CDT* stated, "The act not only gets better but also bigger as time goes on, for every couple of years a new member of the Graham family joins his brothers and sisters in the cast. There are nine of them now performing—ranging in age from Jerry who is 2 ½, to Lorraine, who is 19."

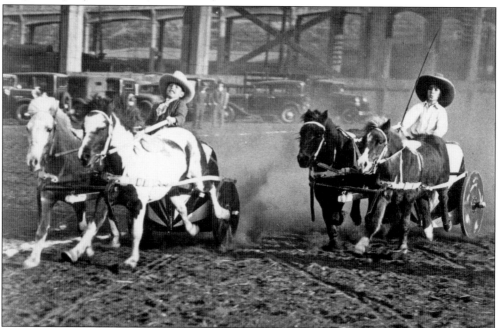

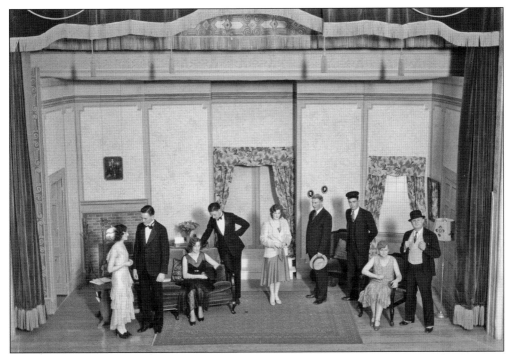

The junior class at the college presented the play *The Patsy* on February 12, 1931. The three-act comedy was under the direction of James R. Start, head of the dramatics department, and had a cast of nine members, including Katherine Rhoades, Ott Weigel, Mary Gayle Reece, Georgia Purma, Gerald Long, Scott Wylie, Tommy Hines, Jewell Royse, and Fred Dellett. The present-day theater used by the drama department is named, in part, for Dr. Start.

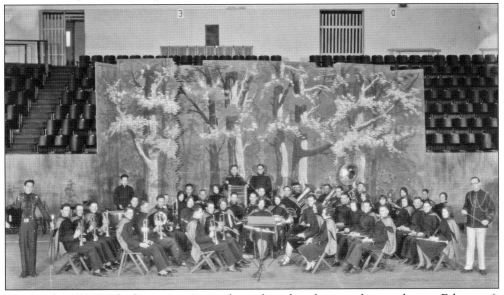

The band at FHKSC had grown to 41 members when this photograph was taken on February 6, 1931. The band was led by Frederick Green. This performance was part of the annual Anniversary Day program, which was also celebrated with a pageant, dance performances, and a reception given by Pres. William and Glennie Lewis.

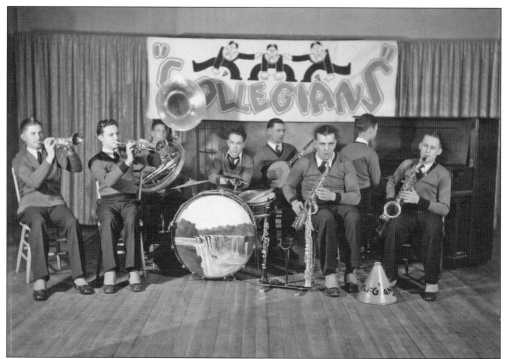

The Collegians orchestra was the official dance orchestra for FHKSC in 1931. This was the group's first year as a dance band and they, therefore, were honored to play for all of the school dances as well as many sorority and fraternity parties. From left to right are Marlyn Kinsley, Melvin Brady, Victory Merryfield, Irwin Corder, David Markel, Gayle Heslet, Gene Cavin, and Ed Serpan.

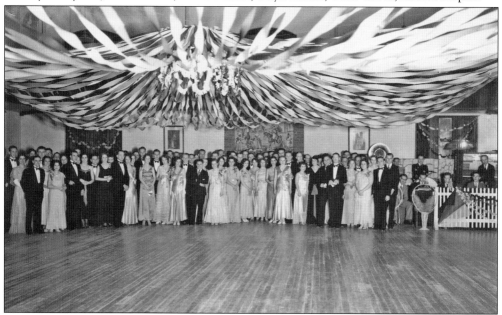

The May 12, 1933, issue of the *HDN* announced that the Phi Sigma Epsilon fraternity would be hosting "an informal spring dancing party" that day. It was held at the Woman's Building and guests included the dean of women, Elizabeth Agnew, whose office gave the building its name.

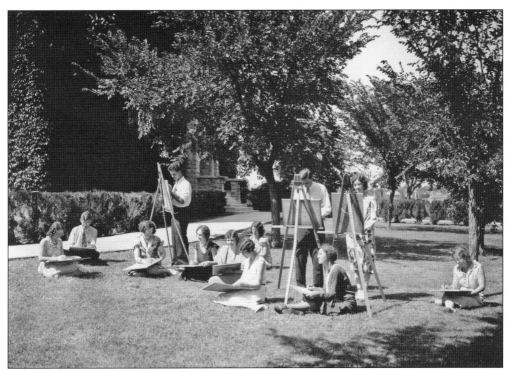

Summer school at FHKSC in July 1931 included art class by Elsie Harris, the professor of applied arts. Besides teaching art, Harris was also the advisor for the Art Lovers Club, a club "established for the purpose of giving those interested in art an opportunity to study its different branches," reported the 1931 *Reveille*.

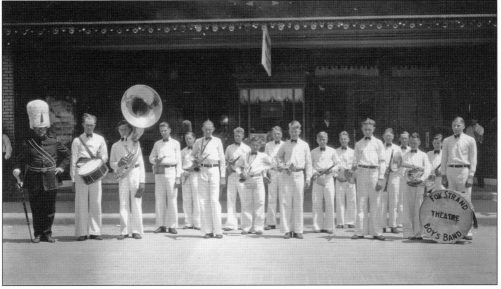

A boys band was organized by the Fox-Strand Theatre in June 1930. The theater celebrated its first-year anniversary under new management with a week of special events. The band members first appeared in their uniforms on June 16, 1930, when they played for both the theater's birthday party and for the grand opening of the Lamer Hotel.

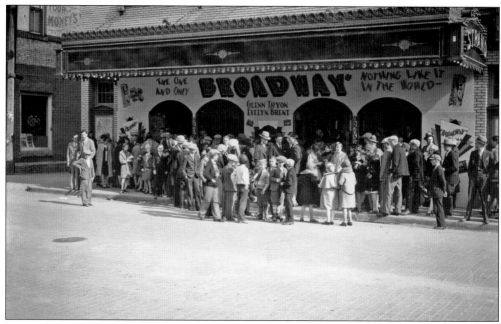

A crowd waits to buy tickets for the two-day-only showing of *Broadway* in 1930 at the Strand Theater on Main Street. The February 22, 1930, issue of the *HDN* stated that the "100% talking, singing, dancing melo-dramatic knockout" picture utilized the newly installed sound system.

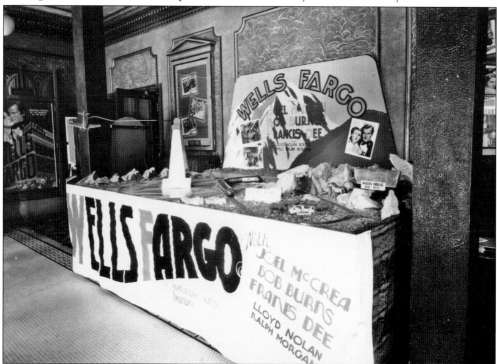

In 1938, the movie *Wells Fargo* played at the Strand Theater for three days in January. This rather elaborate display is in the lobby of the theater. Besides the showing of the movie, patrons also got to see a color cartoon and chapter 10 of the latest serial.

On February 27, 1930, the senior class of Hays High School presented the play *The Automatic Butler*. This farce includes a novel character, especially for 1930—a robot. The play included "a number of distinctive types. The dictatorial mother, the meek, submissive father, the sixteen-year old girl, who is the family pest, the robot, whom the detective calls a 'rowboat,' the clever crook and the mysterious new maid all have parts in the play," reported the February 26, 1930, issue of the *HDN*.

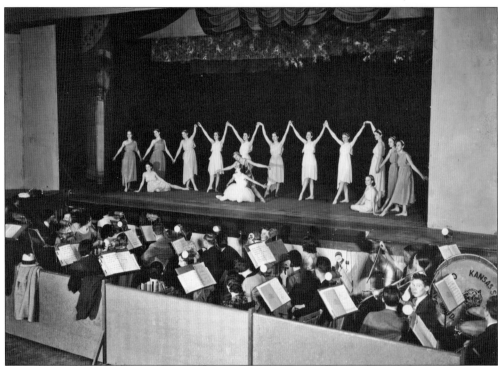

Members of the Orchesis dance group at FHKSC performed with the music department in November 1933 as part of homecoming festivities, as well as the state teachers association meeting held at the same time. "The Dance of the Hours," from the opera *La Giaconda* by Amilcare Ponchielli is shown here.

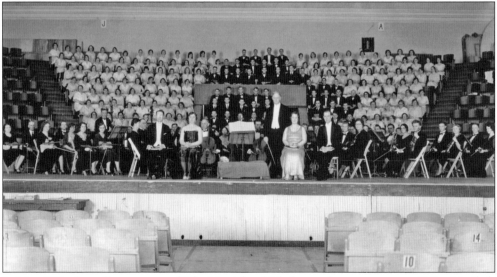

In May 1931, the college presented *The Messiah*, which featured a guest quartet. "Miss Meribah Moore of the University of Kansas will sing the soprano part; Mrs. Ray Havens, of Kansas City, will be the contralto; Prof. Hobart Davis, Kansas State College, will sing tenor; and Mr. Earl Danly, of New York, will sing bass," stated the March 26, 1931, issue of the *Leader*. This concert kicked off the annual music festival.

Helen Frances Bice was a student at FHKSC starting in 1933. She was very active in sports, including the dance program. She gave dance lessons to young students in the area while she was going to school. Seen here in 1936, her students often performed for meetings and groups, such as the nurse's convention in May 1936.

"The Girls Catholic High School Alumnae Association provided an evening of fun for a large audience last night at the high school auditorium in the presentation of 'Through the Keyhole,' a comedy in three acts by William F. Davidson," stated the February 21, 1938, issue of the *HDN*.

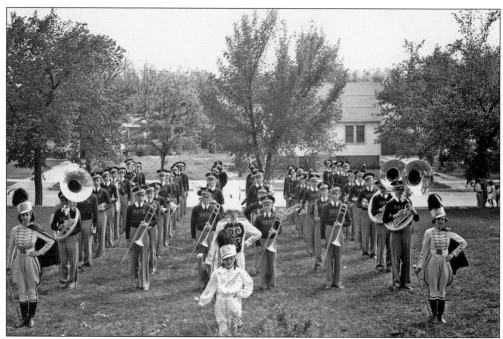

The Hays High School marching band, above, and the St. Joseph's College and Military Academy marching band, below, were busy groups in 1938. Besides their regular duties during the football season, both bands also took part in the spring in the FHKSC music festival, the American Legion parade, a circus parade, and performed during a program sponsored by the Hays Chamber of Commerce, where a crowd of 2,600 people enjoyed the combined band concert. "The St. Joseph's, Hays High, and the State College band, massed played several numbers during the program," stated the March 1938 issue of the *Cadet Journal*.

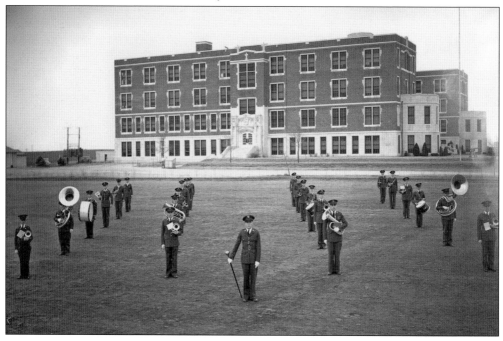

Two

EDUCATION

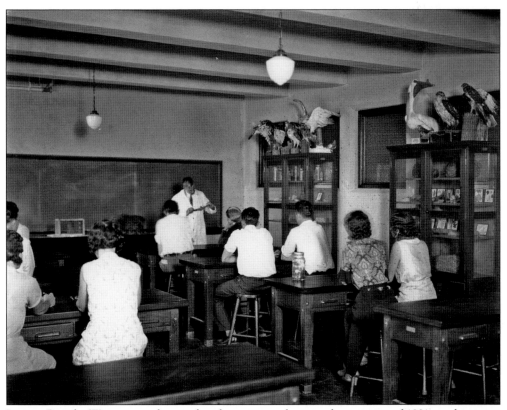

Lyman Dwight Wooster, professor of zoology, is seen here in the summer of 1931 teaching one of his classes. Wooster began teaching at FHKSC in 1909 and ended his career as president of the college, from 1941–1949. He wrote a history of FHKSC after he retired. In this history, Dr. Wooster explained his philosophy of education in this way, "The over-all objective and function of education in America is to prepare people for responsible living in a democracy."

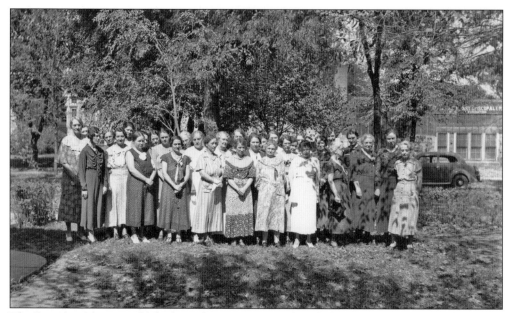

The Saturday Afternoon Club, shown here in 1935, was founded in 1895 with 13 charter members. In 1899, the club decided "to do something for the good and welfare of their city," reported the November 19, 1936, issue of the *ECN*. One of the founders, Etta Ward, was appointed chairwoman of the library committee that year and began soliciting books and magazines for the reading room. The reading room would ultimately grow into the Hays Public Library.

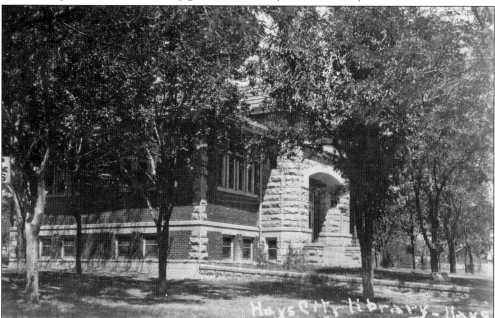

The Hays Public Library was built with a grant of $8,000 from Andrew Carnegie and opened in July of 1911. Located on Main Street behind the county courthouse, the library was in the heart of town and was a vibrant part of people's lives. Beginning as a small reading room, in 1930 the library contained 6,254 books and had a circulation of 14,769. By 1935, the library contained 8,612 books and had a circulation of 21,012.

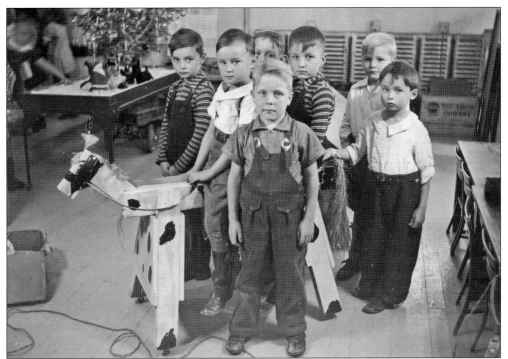

The William Picken Training School began as a six-week summer school. However, starting in 1931 it became an institution catering to kindergarten through junior high students with a high school soon added. The 1933 *Reveille* related, "The school is open to boys and girls of school age irrespective of residence. . . . All the facilities of the college such as the gymnasium, the swimming pool, the library, and the college laboratories are used by the pupils just as they are used by the students in the college." The September 10, 1931 issue of the *Leader* reported, "With a full time supervisor and a group of assistant teachers under her immediate direction, with special opportunities for work in music, art, health and physical education, pupils are offered unexcelled educational advantages." In 1936, the training school became an elementary school only, and in 1939 the training school ended. These pictures are from December 9, 1937.

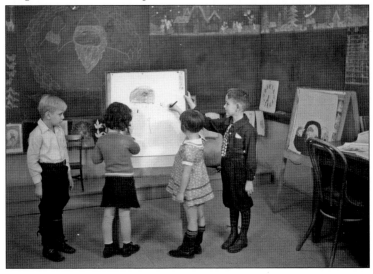

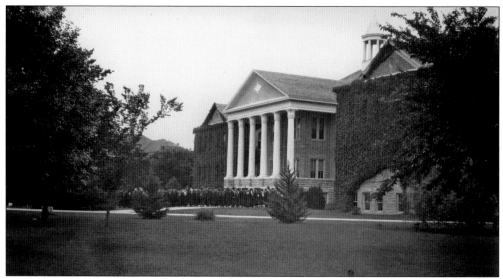

The first building constructed for the new Normal School (later FHKSC) was its Administrative Building, completed in 1904. It would ultimately carry the name of the first administrative head of the college, known as the principal, William S. Picken. Shown here on May 23, 1930, Picken Hall was the area where graduating classes would line up for commencement.

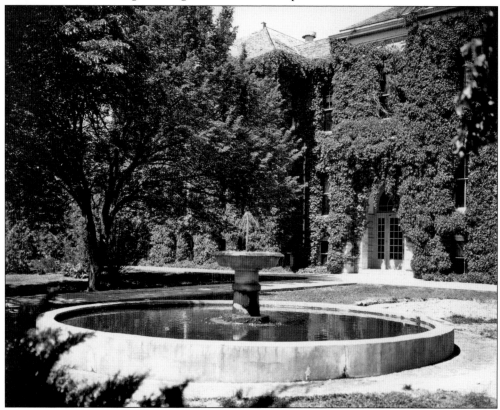

The front of Picken Hall had a lily pond and fountain as part of its landscape. In the late 1930s, the pond and fountain were repaired and faced with native stone. This image is from 1931.

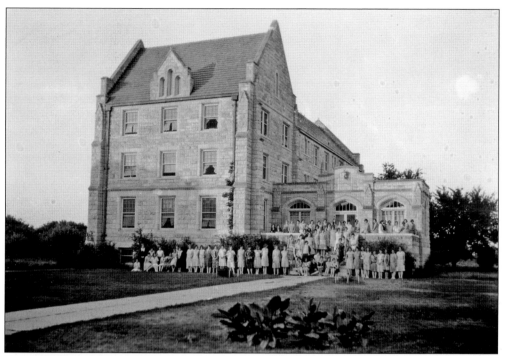

Custer Hall was the first student housing owned by FHKSC. Built in 1922 and named for Elizabeth Bacon Custer (wife of George Armstrong), Custer Hall housed over 80 women. This photograph is from July 18, 1930, and shows the women living there for the summer session.

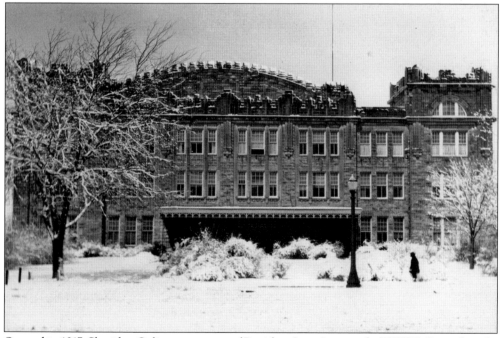

Opened in 1917, Sheridan Coliseum was part of President Lewis's vision for FHKSC. Some thought the auditorium was too large, but Lewis proved them wrong when it was filled the first time it was used for a public performance. It is shown here in the winter of 1931.

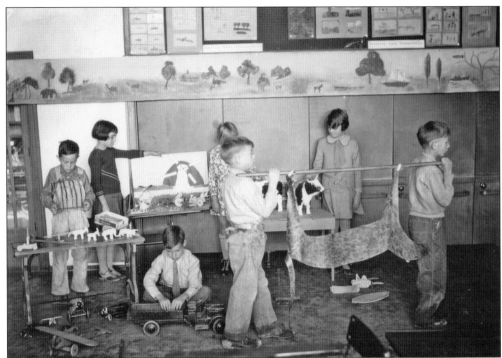

In 1925, the Hays Board of Education issued $130,000 in bonds to build two new grade schools. Washington Elementary School, located at 305 Main Street, served students who lived south of the railroad. The first principal was D. O. Hemphill. In 1930, when these photographs were taken, the principal was Gaynelle Davis. Ethel J. Jones taught kindergarten, Miriam Picking first grade, Ruth Beagley second grade, principal Gaynelle Davis third grade, Myrtle Newbold fourth grade, Mary T. Brown fifth grade, and Goldie Proffitt sixth grade.

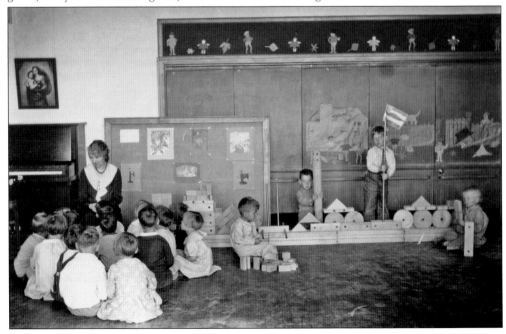

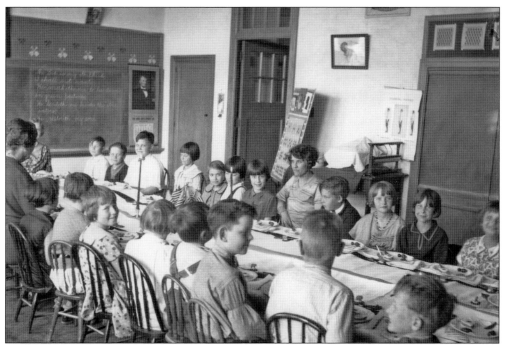

Lincoln Elementary School was built in 1925 and served students living north of the Union Pacific Railroad. In 1931, Annabelle Sutton was the principal and also taught first grade. Sylvia N. Hellman taught kindergarten, Dorothy Dopp second grade, Anna D. Havemann third grade, Enid Bond fourth grade, Laura E. Wells fifth grade, and Minna Koestel sixth grade.

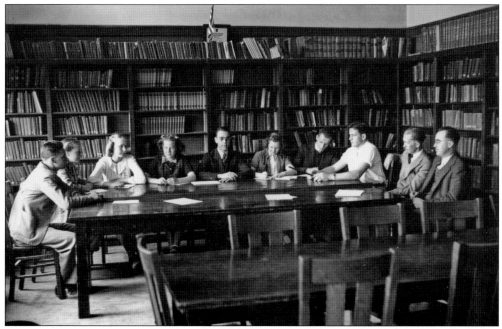

The Hays High School Student Council held its meetings at the school library, shown here in 1939. The three class presidents for the year were Robert Plumb, Gale Doner, and Margaret Corwin. Besides the class presidents, the council was made up of representatives of advisory groups.

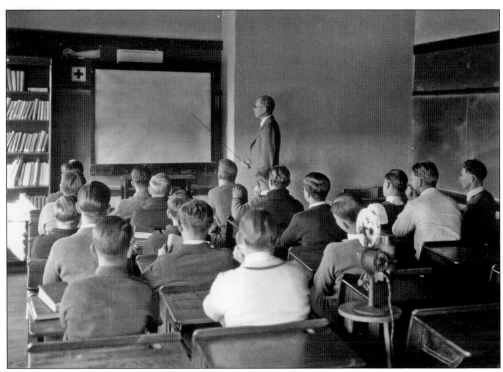

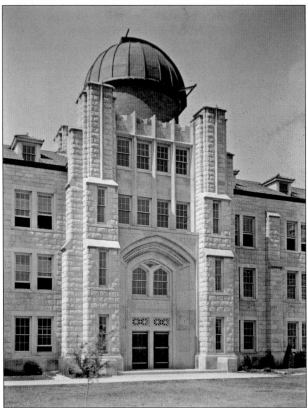

Fred W. Albertson came to FHKSC in 1918 to teach agriculture. In the 1920s, Albertson was the first person to teach "visual education." He arranged for stereopticons and movie projectors to be used on campus. He wrote articles advocating the use of these machines and promoted their use to his colleagues. Here he is using one to teach this class in 1931. The science building, pictured at left, would later be renamed in his honor. Science Hall, now Albertson Hall, was opened in 1928 and included an observatory on the top.

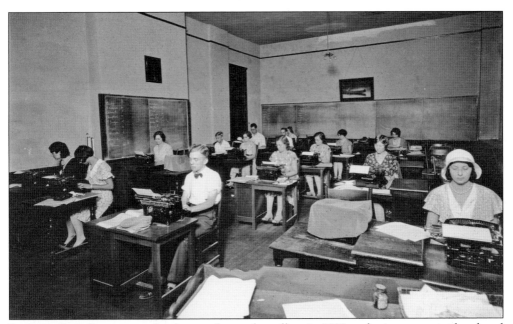

Ruth Estella Bell was a new faculty member at the college in 1930 as the instructor in shorthand and typewriting. She left the faculty in the fall of 1931. In the brief time she held that position, the college grew from being the Kansas State Teacher's College to Fort Hays Kansas State College. The change was not in name only, as the college became a liberal arts institution and the position Bell had held disappeared.

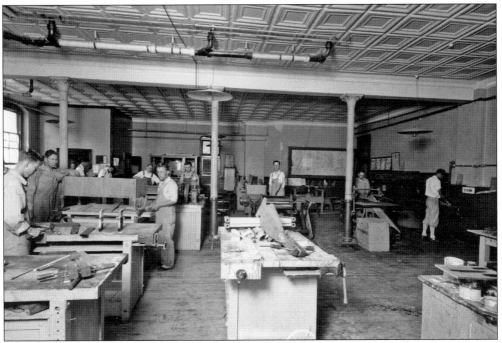

In 1931, Edwin Davis was the professor of manual arts. This is one of his classrooms that year. The classes met in the Industrial Building, which eventually would be renamed in honor of President C. E. Rarick.

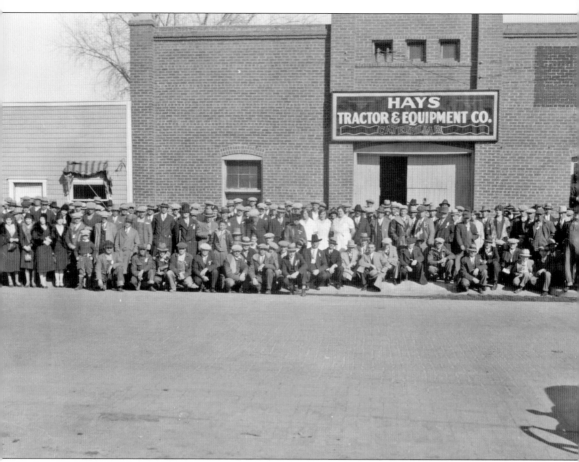

In January 1931, the Caterpillar Company sponsored a two-day tractor and farm machinery school for the Hays Tractor and Equipment Company. Four hundred people attended the "illustrated lectures, talking pictures and silent pictures used . . . in giving instruction in the use and care of farm machinery. The sessions closed after a special meeting at which agricultural classes at the Hays State College were present. Free luncheons were served to the registrants at the school both days," reported the January 29, 1931, issue of the *ECN*.

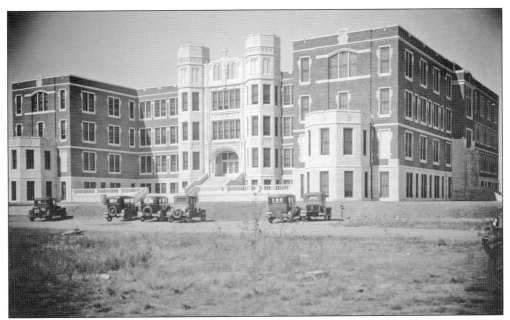

St. Joseph's College and Military Academy dedicated this new building on October 11, 1931. It was under the direction of the Capuchin Fathers of the Province of St. Augustine. The school at this time included a curriculum that included junior high school, senior high school, and junior college, "providing the following courses: Thorough and complete business and commercial courses, complete vocational agriculture courses and pre-professional courses," stated the 1932 SJCB.

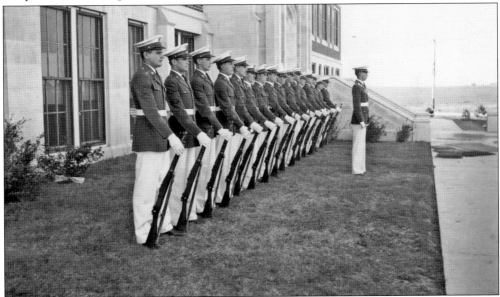

A large part of the curriculum at St. Joseph's College was its military training program. The program "combines and coordinates the institution's entire moral, mental and physical training. The Cadet is taught perfection and mastery of both mind and body. . . . This training does not develop militarism, but on the contrary it does develop a sane and conscientious understanding of the value of maintaining a just and honorable peace within the nation and between the nations," stated the 1932 SJCB.

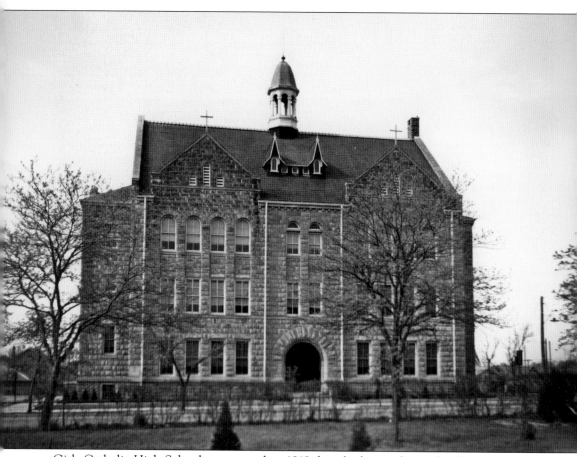

Girls Catholic High School was started in 1918, largely due to the work of Sr. M. Remigia, Congregation of Sisters of St. Agnes (CSA), who went to area businessmen and parents and solicited the finances that were needed. In 1931, when St. Joseph's Academy built a new school, the Girls Catholic High School took over the building St. Joseph's had once used. This photograph of that building is from April 1938.

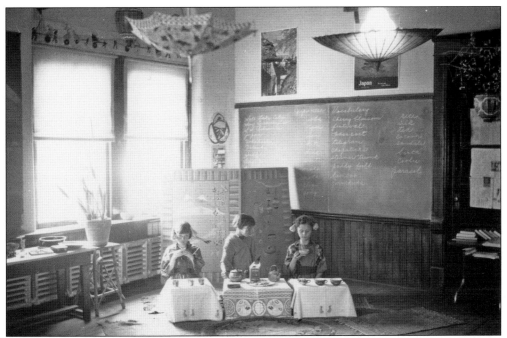

Pearl G. Cruise was head of the supervised teachers' training department in 1931 when she was asked by the college newspaper about when she was 21 years old. "I was very much satisfied with myself, for I had just completed my second summer in a normal school. I taught for $32 per month in my home town . . . I owned a white pedigreed bulldog and had never heard of Kansas. . . . My interest in education, music and dogs still continues, but of course my work is really in the training of teachers," reported the February 5, 1931, issue of the *Leader*. In March 1937, Cruise was teaching at the Picken School, and her students, shown here, demonstrate what they were learning about the Far East and its cultures.

Picken Hall, the Administrative Building of FHKSC, is shown here from the campus side of the building in March 1931. The two end wings were added to the center section of this building in 1908. Since it was the first permanent structure on campus, it served many uses, including the first auditorium and the library.

Three

PEOPLE

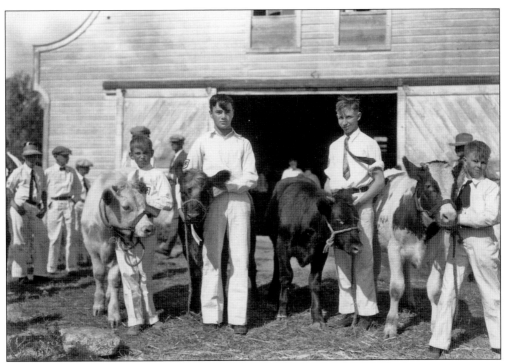

In 1930, a 4-H Club was founded in Hays and the surrounding area to be known as the Junior Farmers 4-H Club. Membership in the club was open to young people between the ages of 10 and 20 years. The boys "will devote their interest to pig and calf raising projects and the girls to cooking and sewing," reported the June 5, 1930, issue of the *ECN*.

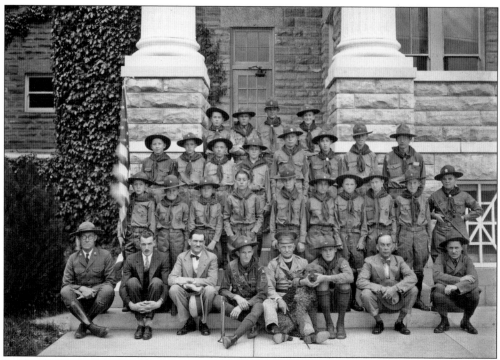

In May 1930, two patrols of Hays Boy Scouts, the Mohican patrol of Troop 59 and the Comanche Patrol of Troop 54, spent the weekend camping on the John McDougall farm, 30 miles southeast of Hays. The outing was the prize for awards won in their troops. The next year, 17 Boy Scouts from Troop 59 returned in August from a week at Brown's Memorial Camp in Abilene, Kansas. The group passed a total of 98 tests. The August 20, 1931, issue of the *ECN* related, "The boys said they didn't have time to get homesick. The bugle and gun called them from slumber at 6:30 a.m. and put them to rest at 9:30 p.m. In between it called them to their various tasks in rapid succession so they had no time to think of home, or anything else except the work at hand."

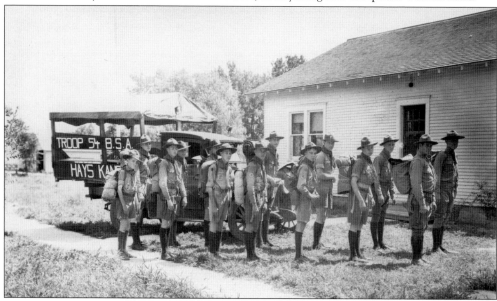

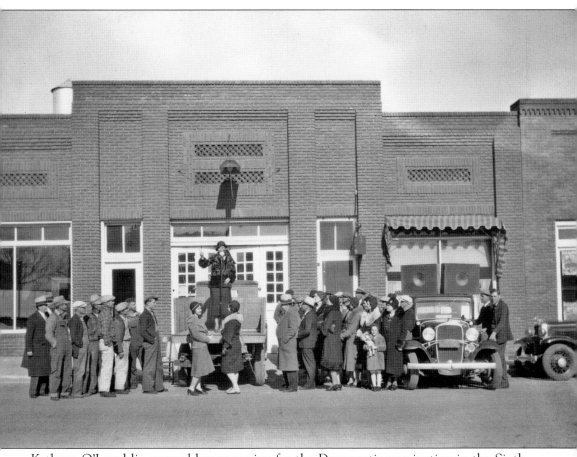

Kathryn O'Loughlin opened her campaign for the Democratic nomination in the Sixth Congressional District in April 1932. In an effort to bring out the largest women's vote in the district, O'Loughlin for Congress Clubs were formed. O'Loughlin is shown here in September of that year making a campaign speech outside of her father's car agency. She was a native of Ellis County, attended school in Hays, and graduated from the college and then law school at the University of Chicago. O'Loughlin won the nomination and the election, making her the first woman sent to Congress from Kansas.

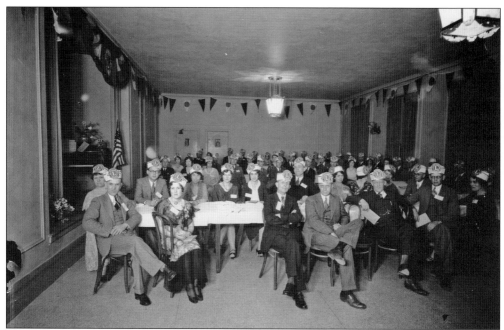

The district meeting for the Lions Club was held at a dinner at the Lamer Hotel on May 14, 1931. The towns represented included Hays, Great Bend, Lacrosse, McCracken, Ness City, Oakley, and Phillipsburg. Along with dinner was a full evening of musical entertainment that included vocalists as well as violin and cello solos.

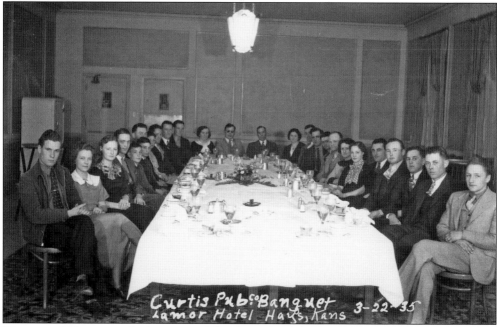

The central Kansas rural sales group of the Curtis Publishing Company held a banquet at the Lamer Hotel on March 22, 1935. The company published such magazines as the *Saturday Evening Post* and the *Ladies Home Journal*. The banquet was in honor of A. E. Trexler of Plainville, who was promoted to the position of rural sales manager.

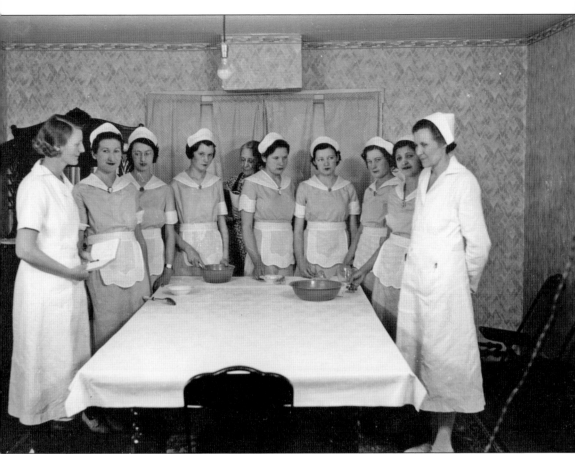

One of the programs of the WPA in 1936 was to train women in the art of homemaking. This included lessons in cooking and sewing in addition to training in budgeting and meal planning. Women who finished the training received a certificate and a recommendation to help them secure a job as a maid in either a public establishment, like a hotel, or in a private home.

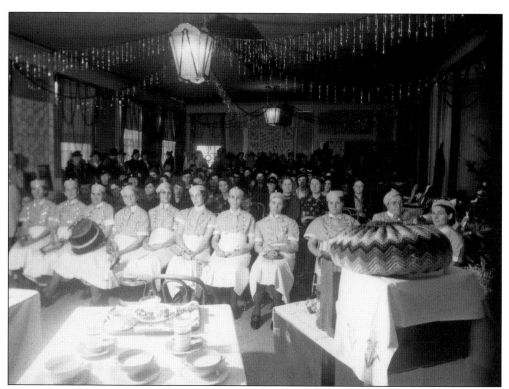

As Christmas neared in 1937, there were several families in need. In order to raise enough funds for Christmas baskets for all, there was a benefit dinner and dance held on December 18. It took place at the Lamer Hotel and was sponsored by several groups, including the Lions Club, the Rotary Club, and the Lamer Hotel. Various items were donated to sell to help raise money as well.

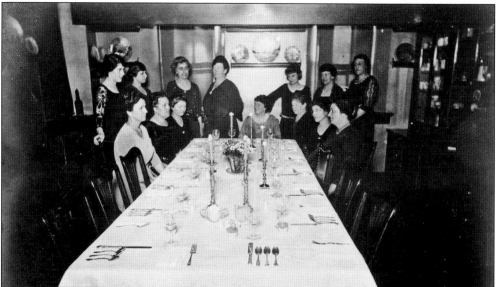

Glennie Lewis, the widow of the college president, continued to be active in the community and college after her husband's death. In 1936, she helped with the College Faculty Wives Club, which often had luncheons and dinners as part of their meetings.

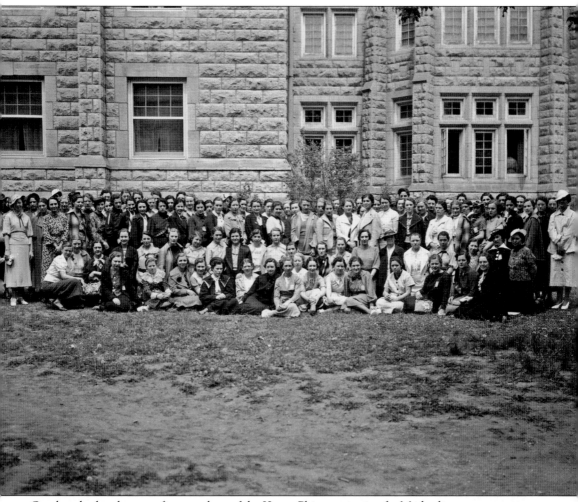

One hundred and twenty five members of the Kappa Phi organization for Methodist young women met in Hays the first part of May 1936. It was the 20th anniversary of the founding of the organization. The district meeting included three days of meetings and special events, including, as reported in the May 1, 1936, issue of the *HDN*, "A pioneer dinner at the Methodist church . . . a 'hill top breakfast' at the stone quarry, west of Hays, a luncheon at the Methodist church with the theme 'Women Who Have Made History' and a Mexican tea Saturday afternoon."

The December 16, 1937, issue of the *ECN* stated, "William Baier of Victoria, was elected president of the Ellis County Farm Bureau at the fourth annual meeting of the organization at St. Joseph's college. . . . Three hundred and fifty farmers and their families braved the icy roads to attend the meeting which is the annual 'big event' socially and in point of business for the Farm Bureau."

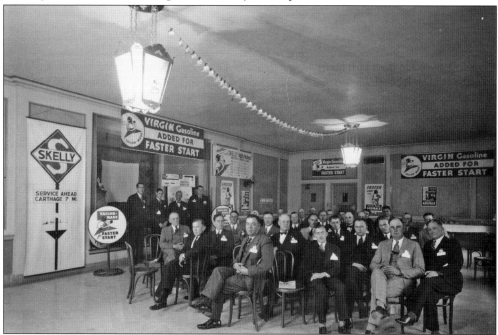

The October 23, 1936, issue of the *HDN* related, "Forty dealers, distributors, and jobbers from Western Kansas towns attended a regional meeting of the Skelly Oil Company at the Lamer hotel this afternoon." Following a luncheon, the business part of the meeting included announcing the company's advertising and sales campaigns for the following year.

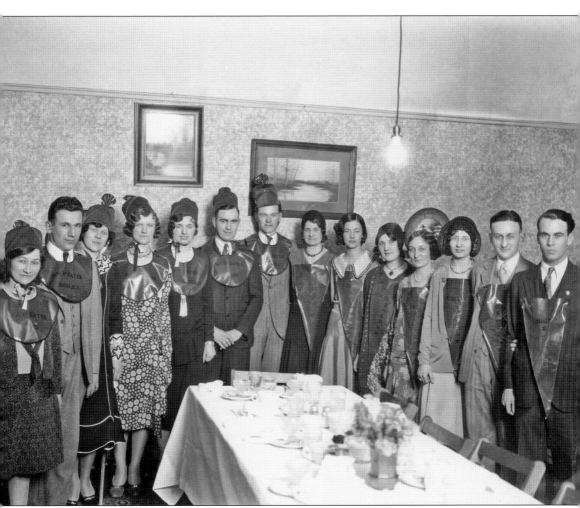

In April 1930 the J. C. Penney store hosted a turkey dinner for its employees. It was held at the Brunswick Hotel and seems to have been a festive affair. It remains a mystery as how one was designated as either a "Soup Eater" or a "Winner." As part of being a "Soup Eater," one seems to also have had the privilege of wearing an attractive hat.

The First United Methodist Church in Hays began an ambitious building project in the 1920s. By the 1930s, the construction included the basement, parlor, and Wesley Hall. While the completion of the church took until the late 1940s, the congregation carried on using the portions finished at that time. These photographs from April 1938 demonstrate that. Marlyn Storm's history of the Methodist Church states, "They had five teachers for their Sunday Schools, had a choir of about 25 voices for evening services, held four or five general student receptions during the school year, with numerous smaller social mixers, a Friday night open house (average attendance nearly 100) with various games such as ping pong, chess, checkers, darts."

Most of the churches in 1934 had youth groups and the Baptist church was no exception. This is the girls' youth group meeting in early December to make plans to help with the bazaar the Baptist Ladies held each year.

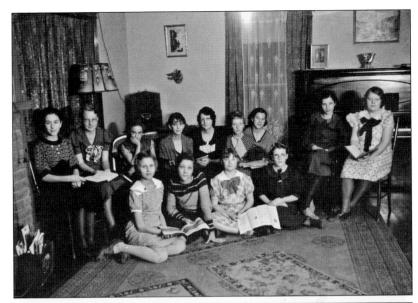

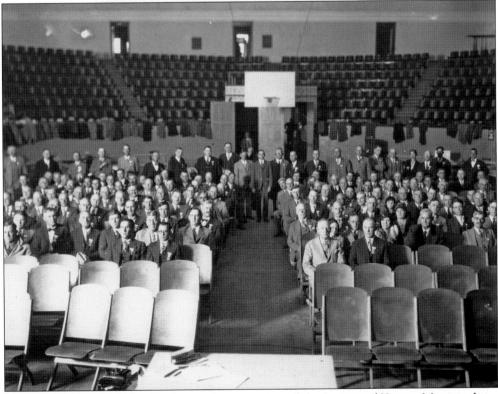

On October 20, 1930, the 22nd annual convention of the League of Kansas Municipalities began its three-day meeting. More than 65 Kansas cities and towns were represented. They met at Sheridan Coliseum at Fort Hays Kansas State College. They discussed problems and issues from the various cities, such as requesting from the state legislature a portion of the "cigarette venders' license tax, gasoline tax and motor vehicle license fees be retained by the cities," stated the October 20, 1930, issue of the *HDN*.

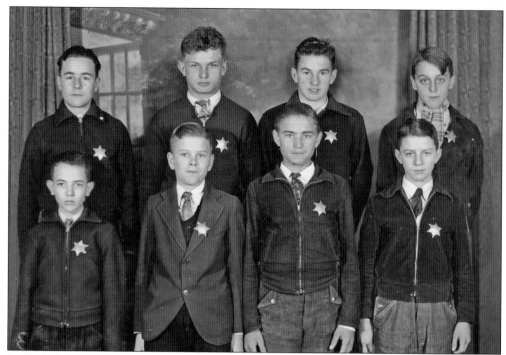

In 1936, there was a youth group referred to as the St. Joseph Police Boys Club. As their badges state, they were "special police," yet these groups were actually educational programs dealing with youth crime and also included sports and recreational activities.

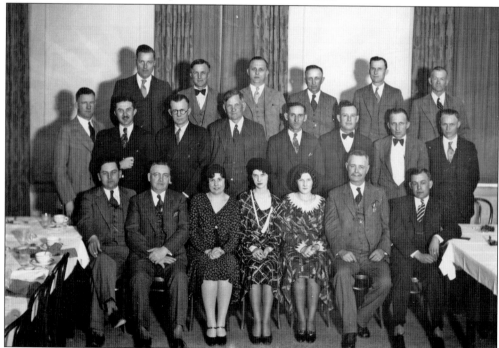

The United Telephone Company held district meetings every Tuesday starting in March 1931. At these meetings, the employees would receive additional training and accreditation as well as dinner.

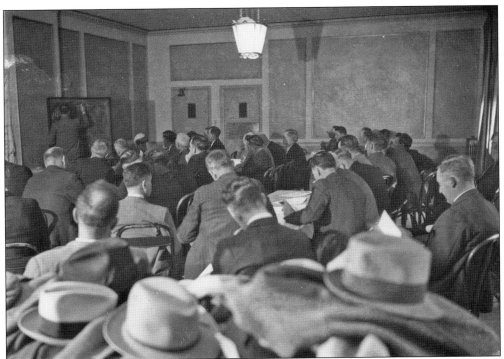

In December 1934, Hays hosted a school for homestead rehabilitation workers held at the Lamer Hotel. Rehabilitation corporations were organized in Kansas in 1934–1935 to help in the administration of the funds the federal government was providing from the Emergency Relief Act of 1933. The school held in Hays represented 21 western Kansas counties.

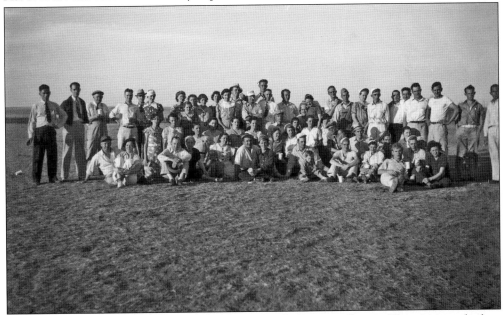

On September 19, 1936, the Lamer Hotel held a picnic for its employees. The picnic took place on the Philip ranch, 9 miles southeast of Hays, and included a rousing game of softball as well as the usual picnicking food and activities.

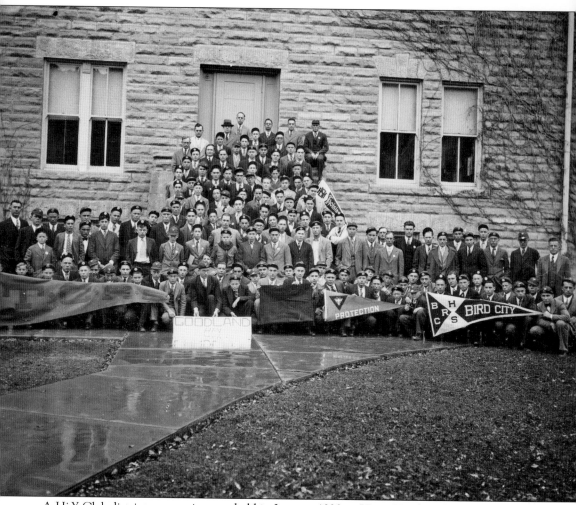

A Hi-Y Club district convention was held in January 1930 in Hays. Two hundred and fifty boys from northwest Kansas attended the weekend event that included two banquets, the college homecoming football game, and several inspirational speakers. The Hi-Y Club was a general name for youth clubs sponsored by the YMCA. The main speaker was Harold Colvin, the state secretary of the YMCA, whose speech was about "personality in the home."

Four

SPECIAL EVENTS

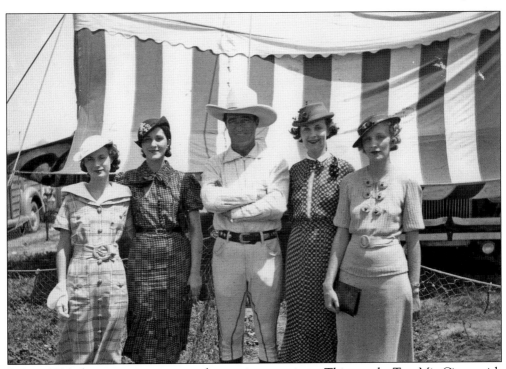

In June 1936, the circus came to town, but not just any circus. This was the Tom Mix Circus with Tom Mix and Tony (his horse) in person. While the circus also included the usual aerial acts, clowns, and animal acts, it was Mix that was the star, performing "a shooting and riding stunt which attracts more attention than anything in his circus, excellent as it is," reported the June 1, 1936, issue of the *HDN*.

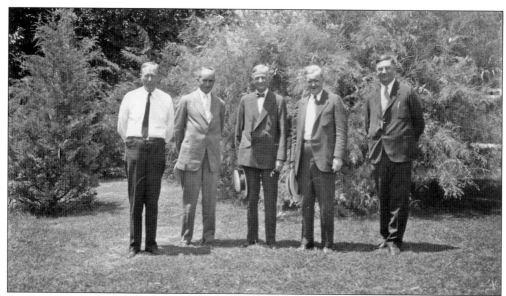

On July 9, 1930, the national agricultural issue of falling prices and too much wheat production arrived in Hays. Secretary of Agriculture Arthur Hyde (above, center) and chairman of the Federal Farm Board Alexander Legge (above, left) met with Kansas governor Clyde M. Reed (above, second from right) in a forum held at Sheridan Coliseum. The position of the federal government was to curtail wheat production. The July 21, 1930, issue of *Time* stated, "Before a large coatless audience in the Hays Coliseum, Governor Reed opened the argument by bitterly flaying the Farm Board's crop reduction program. He declared western Kansas could raise nothing but wheat unless it returned to live stock, asked why crop limitation was not imposed east of the Mississippi River." Legge's response was that there was too much wheat and the farm board had already put too much money into a stabilization program.

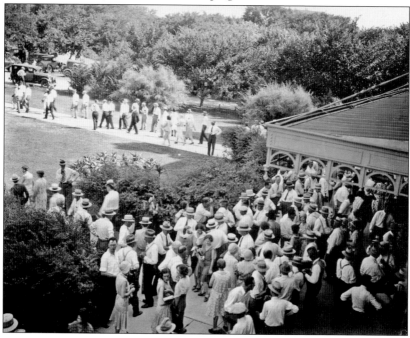

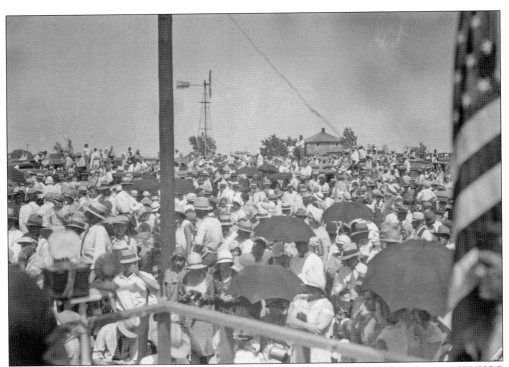

The weekend of June 23, 1931, saw two events being held jointly: the 30th anniversary of FHKSC and the dedication of Fort Hays Historical Park. Vice president Charles Curtis (below) was the guest of honor for the college's birthday party. As a U.S. congressman, Curtis had played a role in the formation of the college. "I have always been proud of the assistance I gave in securing the donation of the old Fort Hays military reservation by the United States government to the state of Kansas for college purposes," Curtis stated in his letter of acceptance to speak as related in the April 8, 1931, issue of the *HDN*.

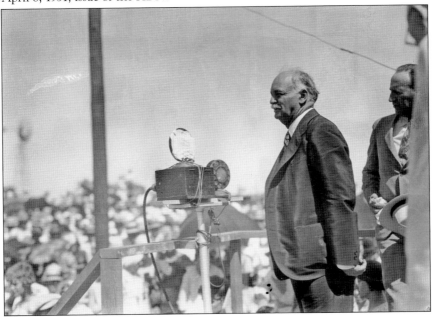

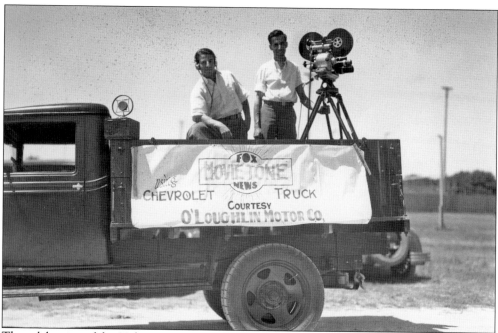

The celebration of the 30th anniversary of the college and the dedication of Fort Hays Historical Park included a parade, a frontier pageant, and a cowboy roundup and rodeo. However, what brought the Fox Movietone newsreel crew to the party were the speakers. Vice President Curtis was the founder's day speaker for the college and Gov. Harry Woodring (below) dedicated the park. Woodring gave a very spirited political speech but also gave a historical review and dedicated the Park as "the Frontier State Park of Kansas. It will be a monument to our pioneers . . . who came in covered wagons with oxen along the dim and dangerous trails that crossed and criss-crossed the plains," reported the June 24, 1931, issue of the *HDN*. In 1933, Woodring would become part of the Roosevelt cabinet.

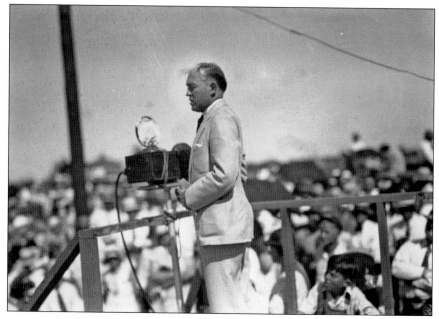

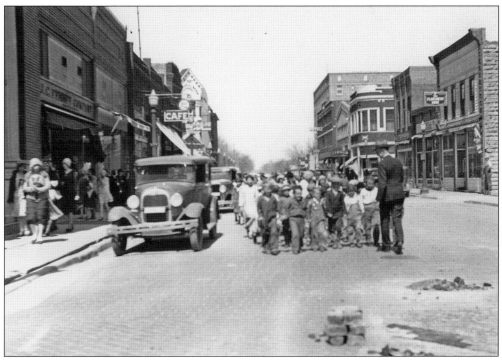

The annual Lions Club Easter egg hunt was held April 11, 1931, at 1:00 p.m. The children met at the courthouse square and were then paraded down Main Street to the location of the hidden eggs. The location was kept secret until the afternoon so that no one would have an unfair advantage. This particular year, the 2,880 eggs were hidden south of Washington School, nine blocks away. Members of the Lions Club worked well into the night boiling and dying the eggs that would later be hidden.

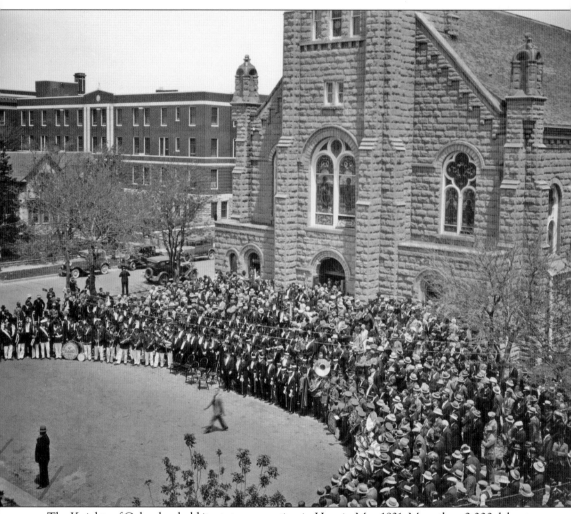

The Knights of Columbus held its state convention in Hays in May 1931. More than 2,000 delegates attended the three-day event, shown here in front of St. Joseph's Church. The delegates included many distinguished visitors, including two bishops, Bishop Francis Joseph Tief and Bishop August J. Schwertner. All the hotels were full, as well as the cottage camps nearby, and the chamber of commerce asked citizens to help by taking people in. The May 15, 1931, issue of the *HDN* reported, "Housewives were polishing up their spare rooms and putting cots in the basements for the family so the visitors may be comfortably housed. . . . At the Lamar hotel, the Fort Hays Function Room will be turned into a large dormitory with rows of cots to accommodate a large number of delegates."

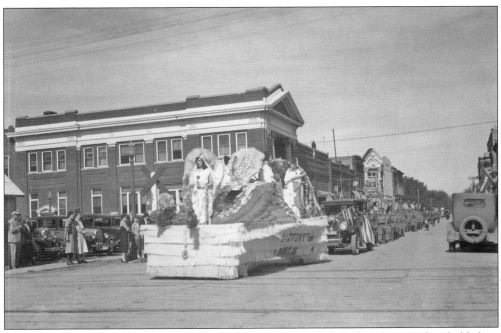

The Independent Order of Odd Fellows (IOOF) and the Rebekah Auxiliary Lodges held their state convention in Hays in October 1931. Nearly 3,000 people had registered in advance to participate in the event, which included meetings, a parade, a banquet, and a military ball. The parade down Main Street included eight bands: the American Legion drum and bugle corps of Hays (below), the Hays High band, the IOOF home band from Manhattan, the Oakley band, the Hill City band, the Ellis band, the Russell band, and the Fort Hays Kansas State College band. There were also floats, and the members of the various lodges all marched. The grand master installed at this meeting, Cecil Calvert, was from Hays.

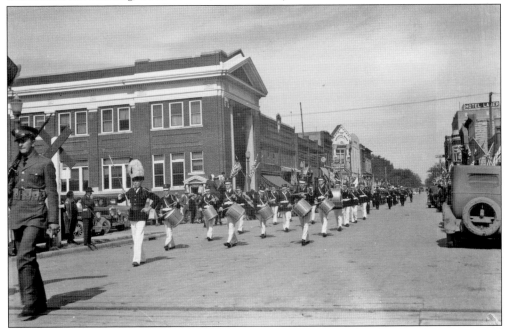

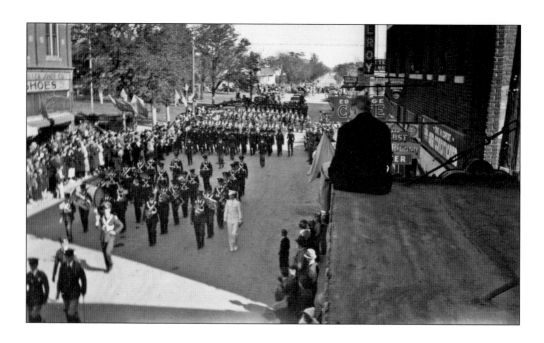

The 70th anniversary of the founding of Hays was celebrated in grand style on October 20, 1937. The historical parade began at 10:00 a.m. marching south on Main Street. The October 19, 1937, issue of the *HDN* stated, "In the parade will be the Kansas State college band, St. Joseph's College band, the Hays high school band, Indians, characters of the early west, horses and riders, old-time vehicles, old-time agricultural implements, units and floats from various organizations." Civic organizations, neighboring communities, schools, 4-H clubs, scout groups, and various businesses had entries. A count of the cars in the area for the parade brought representation from 37 counties and 10 states. Notice in the photograph below the sign for Ekey Studios, the photographer of this collection.

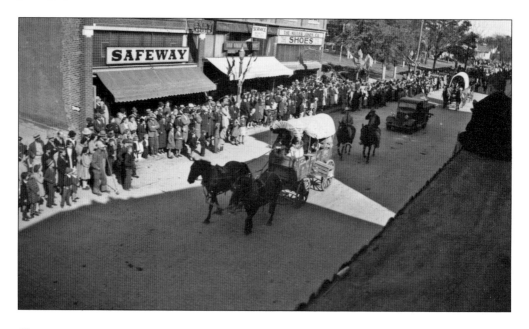

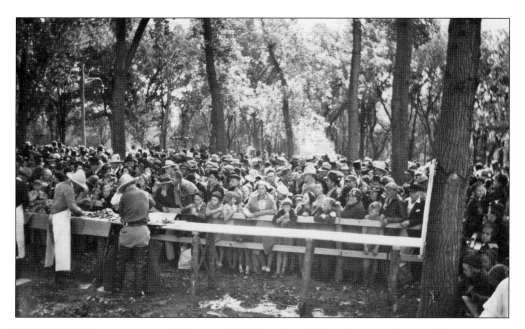

While the 70th anniversary celebration of the founding of Hays began with a parade, many more activities took place that day. There were two softball games, the Lions Club versus the Rotary Club and the farmers versus the city team. There were games for children, like a three-legged race and an egg relay, and that night there was a historical pageant and a street dance. What had to have been the biggest event, however, was the free barbecue that took place in Frontier Historical Park. It was estimated that 10,000 people were served barbecue sandwiches and coffee. "Three beeves and 250 gallons of coffee disappeared like magic as the visitors lined up around the wooden counters to be served. Frank King was in charge of preparation of the beef, which was pre-cooked in ovens downtown and then kept hot over flames in a pit at the park," reported the October 20, 1937, issue of the *HDN*.

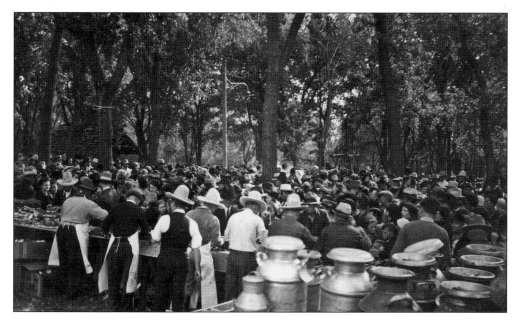

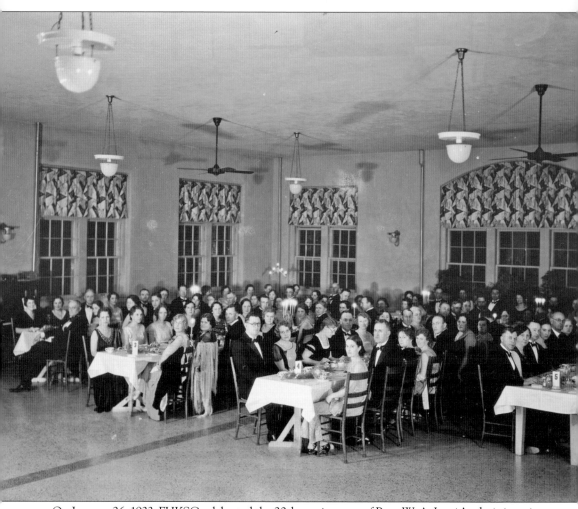

On January 26, 1933, FHKSC celebrated the 20th anniversary of Pres. W. A. Lewis's administration with a banquet held in Cody Commons. The dean of women, Elizabeth Agnew, acted as the toastmistress for the festivities. It was during this administration that the college grew from a normal school to a teacher's college and ultimately to a state college. Lewis doubled the number of faculty to 56 and built six new buildings. At the banquet, he was presented a gold watch inscribed with the college seal with a chain of 20 links, each inscribed with the year of the class it represented. Unfortunately, the next month Lewis suffered a heart attack and never fully recovered, dying in October.

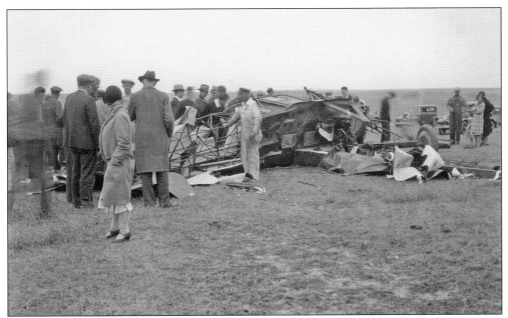

In a pasture west of Hays, this airplane crashed, killing the pilot and his wife. The two other passengers were injured but survived. Air travel in 1930 was dangerous but popular. There had been another fatal wreck the week before at the Hays Airport. "There are problems of air travel that may require many years in the solving, but rapid progress is being made in making ships of the air safe for passengers," reported the April 10, 1930, issue of the *ECN*.

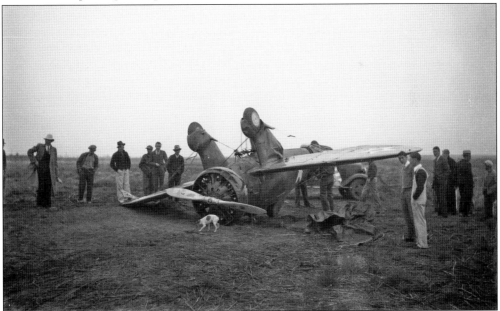

In April 1936, a U.S. Army pilot crashed as he tried to land at the Hays Airport. The pilot escaped injury because help was nearby and they lifted the tail enough for him to get out. The pilot was caught in a crosswind, but according to army officials the "cause of the accident traces to an improperly built and inadequately maintained landing field. . . . My report will result in condemning the Hays airport," stated the April 27, 1936, issue of the *HDN*.

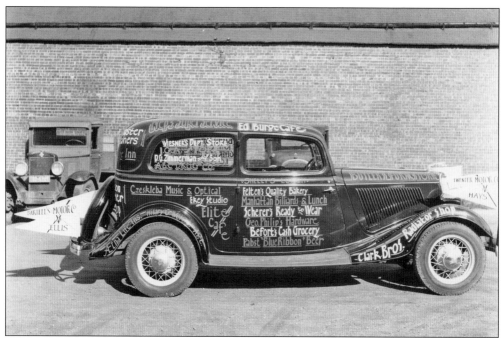

In May 1934, Twenter Motors sponsored a Ford motorcar 100-hour endurance drive. The driver, P. I. Sinner, was handcuffed to the steering wheel as he continually drove the car for a little over four days. Other businesses in town, listed on the car pictured above, helped with the event by furnishing prizes for who could guess the number of miles driven and amount of gas and oil used. Sinner would make stops at the various sponsors' stores as he drove. After finishing the 100-hour, 2,102-mile trip, "P. I. Sinner slept peacefully this afternoon in the window of the Butler Furniture store, completely oblivious to the stares of passers-by, as he rested from his arduous endurance drive in a test of the New Ford V-8 sponsored by the Twenter Motor Company," reported the May 5, 1934, issue of the *HDN*.

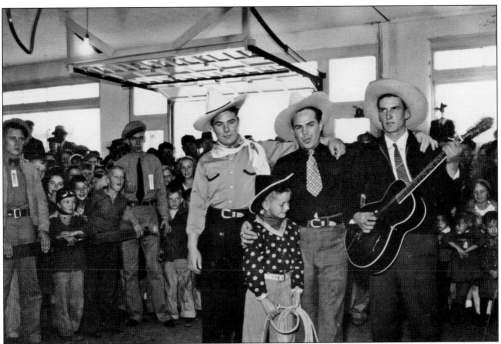

O'Loughlin Motor Sales held its Chevrolet Day on Saturday, November 2, 1935, to introduce the new line of 1936 Chevy cars and trucks. It was a full day of activities starting with Colonel Gorman and his Cowboys, who provided songs and rope tricks for the 1,000 or more people who attended. The FHKSC band then gave a concert before leading a parade of 500 Chevrolet owners driving their vehicles. The afternoon had movies being shown in the South Building, which could hold 300 people; free gifts to the first 50 women; 500 balloons for the kids; and "a box of matches to each and every man . . . as long as they last," related the November 1, 1935, issue of the *HDN*.

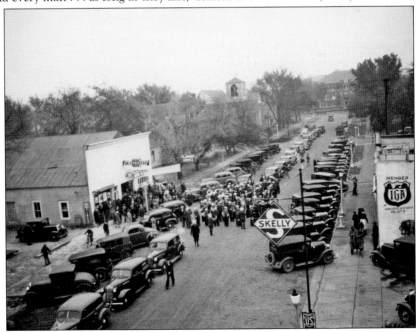

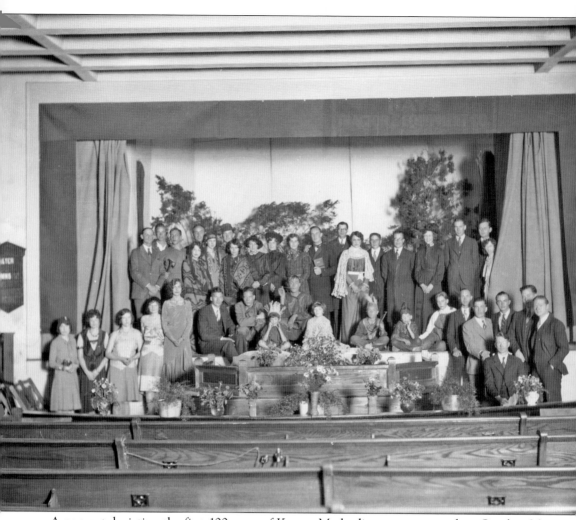

A pageant depicting the first 100 years of Kansas Methodism was presented on October 26, 1930, by the Wesley Foundation Players. The pageant was held at the Hays Methodist Church. It was shown throughout Kansas during the centennial of the first missionaries going to teach the Shawnee Indians. "The play opens with a scene on the Shawnee Indian reservation and shows the Indians in their native condition and the alarm aroused by the news of the coming of the first white men. . . . The trials, sorrows, joys, and triumphs of these early missions in early Kansas are shown in picturesque setting," reported the October 24, 1930, issue of the *HDN*.

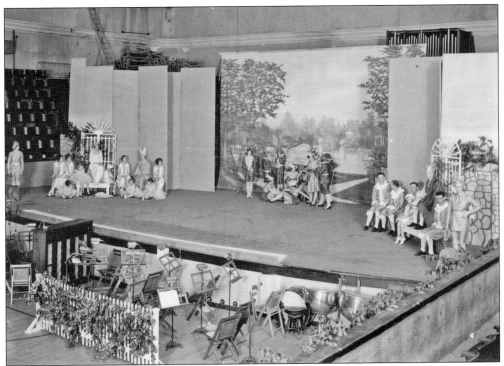

As part of the 1930 music festival, a production of an old English May fete took place in Sheridan Coliseum at FHKSC. The setting was merry old England, where the "Queen of May and the Lord of Revelers sat enthroned to view the festivities of May Day. Colorful costumes, unusual lighting effects and well-trained dances, set to tuneful music combined to furnish an evening of outstanding entertainment," stated the May 3, 1930, issue of the *HDN*. The program was planned and directed by Elizabeth Graybeal of the physical education department and the prologue and epilogue were written by R. R. McGregor of the English department. The performers were students from both the college and the Hays schools.

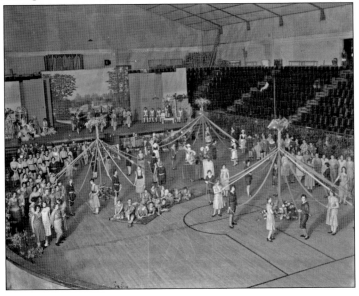

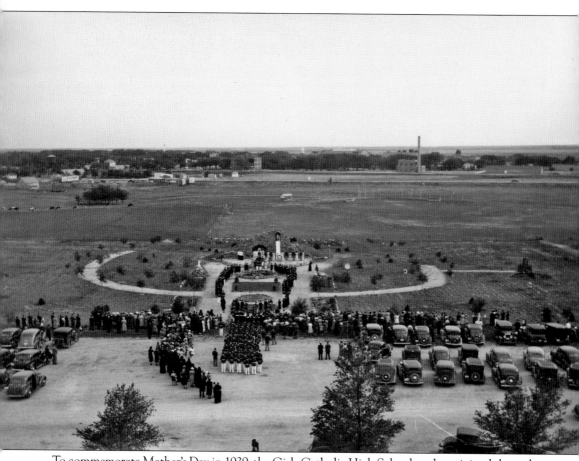

To commemorate Mother's Day in 1939, the Girls Catholic High School students joined the cadets at St. Joseph's College and Military Academy in a May Day ceremony. The program opened in the college auditorium with the crowning of the May Queen. Then the procession marched from the auditorium to the outside grotto, where ceremonies resumed. There was music and pageantry that, according to the May 1939 issue of the *Cadet Journal*, "paid loving tribute to the Heavenly Mother, as well as to the mothers of the whole world."

Five

SPORTS

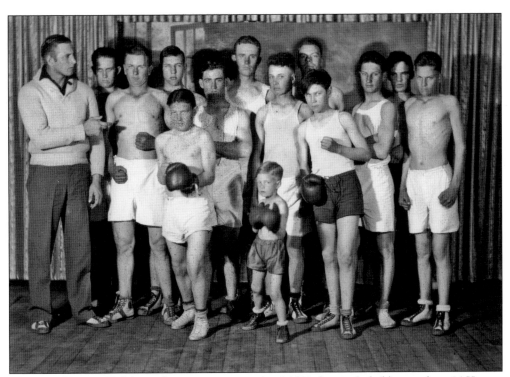

The Hays Boxing Club hosted a tournament in April 1931 that included boxers from 14 Kansas towns. The March 21, 1931, issue of the *HDN* reported, "Nearly 200 aspiring amateur fighters, from giant heavy-weights to tiny fly-weights are planning to enter the big A. A. U. championship boxing tournament here April 8, 9, and 10 under the sponsoring of the Knights of Columbus." Swede Burgwin was the local trainer and said the Hays contingent was looking good.

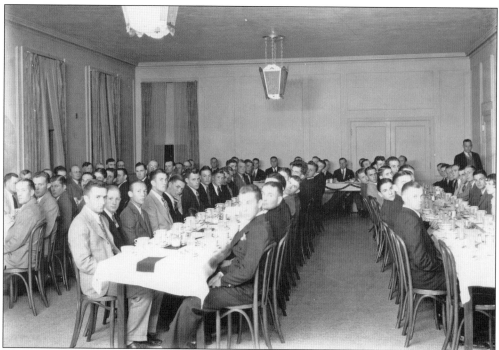

On September 22, 1931, the Lions Club held a football banquet at the Lamer Hotel. Football squads from the three Hays schools—Fort Hays Kansas State College, St. Joseph's Catholic College, and Hays High School—came together to enjoy a dinner followed by entertainment.

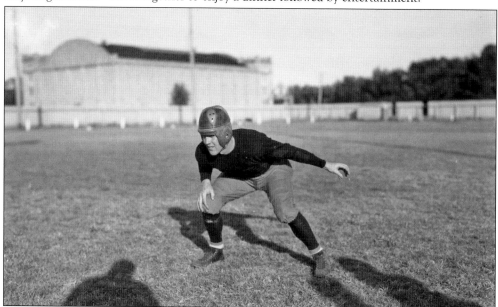

Lee Cashman, tackle for the FHKSC football team in 1931, posed for this yearbook shot. The team was coached by Wilbur C. Riley, known as Jack, and as the *Reveille* related, "While this year's Tiger team did not turn in many victories it was noted for its fighting spirit, never giving up, even against insurmountable odds." The insurmountable odds undoubtedly included the 61-0 score of the Wichita game.

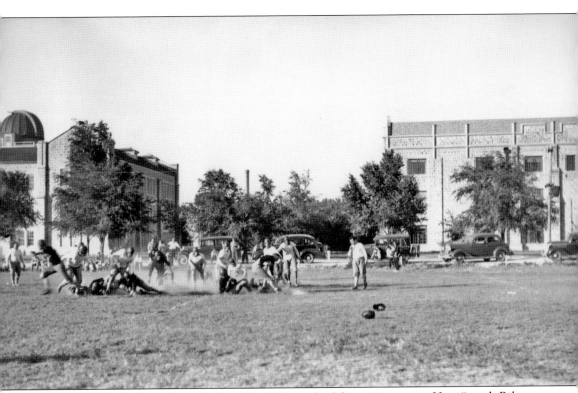

The FHKSC football squad practiced on the field south of the main campus. Here "coach Riley is working his squad at top speed in order to have them ready for the opening whistle at Greeley, Colorado Teachers," reported the September 15, 1932, issue of the *Leader*.

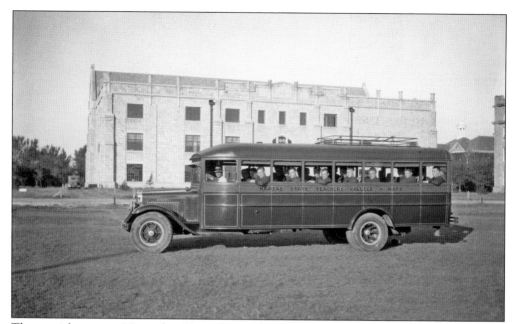

The special game on November 11, 1930, saw the FHKSC football team head to Salina in its International Harvester bus to face the Kansas Wesleyan team. Since it was Veteran's Day, there were no classes, so students could attend the game although it was a Tuesday. There was such excitement for this game that the Union Pacific Railroad arranged for a special train to take students from Hays to Salina.

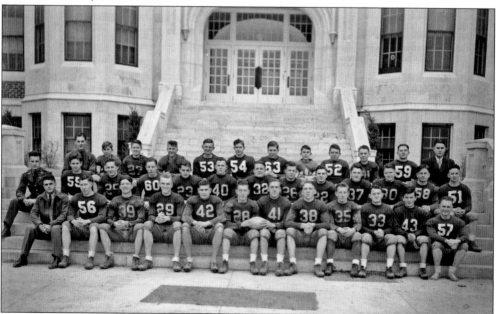

The St. Joseph's College football team was the undisputed Union Pacific league champion in 1936. The December 1936 issue of the *Cadet Journal* reported, "The Cadets rolled up 140 points to 37 for their opponents, a ratio of approximately 4 to 1. All league games were won decisively. . . . Outside the league, however, the squad met defeat in three of their five games, and drew one tie, which might suggest that they missed the support of the student body."

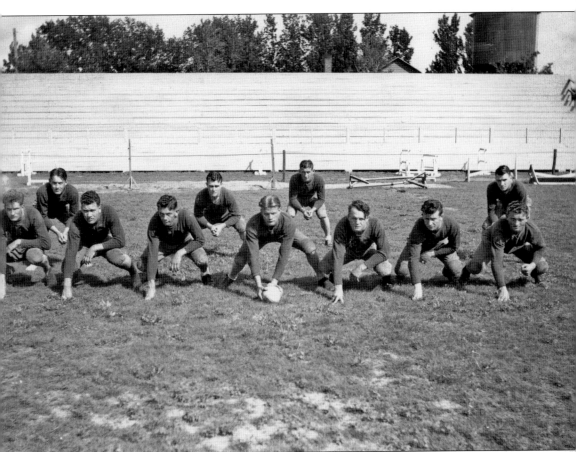

In 1936, the Hays High School football team played eight games, with the last being a Thanksgiving Day matchup in neighboring Ellis. That game ended in a 7-7 tie. This was also the year of new uniforms with new colors. "The new football jerseys are a brilliant red with 10-inch gold numbers on the front and 8-inch gold numbers on the back. The change of color was made from purple and gold to red and gold so that the Hays team would have an entirely different color from that of any other team in the Union Pacific league," stated the September 21, 1936, issue of the *HDN*.

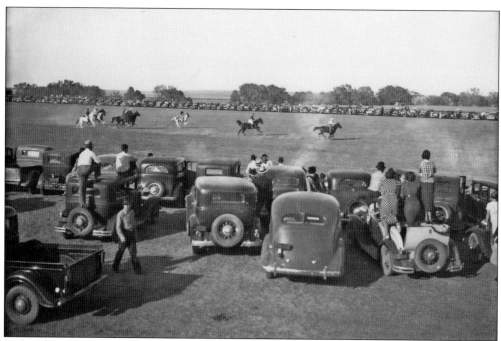

In October 1936, the Philip ranch was the scene of an "oil party." A barbecue, dance, and polo match were held to celebrate the finding of oil on the ranch. Over 3,000 people attended this free celebration. The polo field was created when the cars driven to the event were lined up two- and three-deep in a large rectangle. The October 20, 1936, issue of the *HDN* reported, "W. D. Philip, Sr., his five sons, his nephew, Scotty Philip, Rich Bissing and Major Cook demonstrated Western Kansas polo in which hard riding is employed to make up for inexperience with the mallets. On one team were Douglas Ward and Morton Philip and Rich Bissing with Major Cook later replacing Morton. This group won, 7 to 2, from a group including W. D. Philip Sr., W. D. Philip, Jr., Philip Philip, and Scotty Philip."

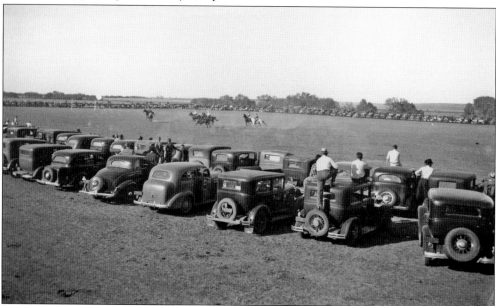

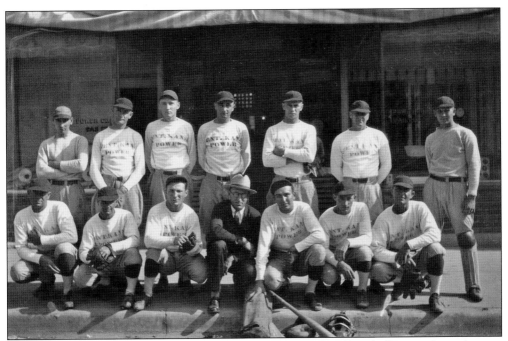

The Central Kansas Power and Gas Company sponsored a local baseball team, shown here in 1930 posing in front of the power company's office. A county baseball league was organized in 1928 to include several towns that would play each other each year. In September 1930, there was a celebration on the Nick Pfannenstiel farm southeast of Hays that included pony races, harness races, a rodeo, and baseball games. That afternoon, the Pfeifer team beat the Severin team 4-1.

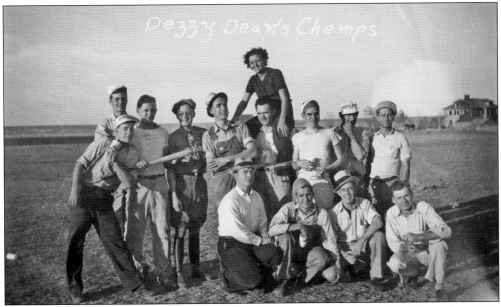

The Lamer Hotel staff enjoyed their annual picnic at the Philip Ranch in September 1936. "Soft-ball, horseback riding, and a picnic luncheon were on the schedule for the afternoon," stated the September 24, 1936, issue of the *ECN*. Shown here is the softball team, the Dezzy Dean's Chemps.

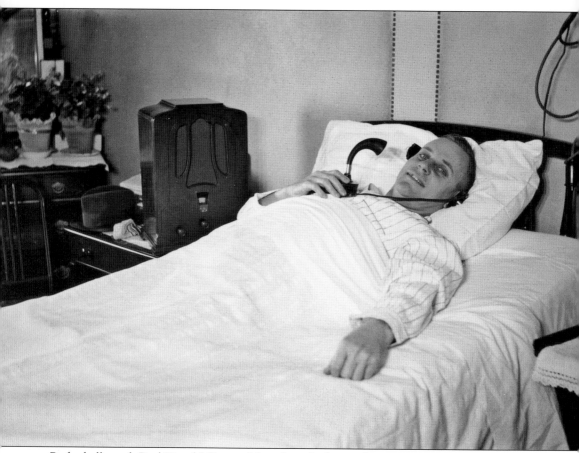

Basketball coach Paul "Busch" Gross, although in the hospital recovering from a back operation, still found a way to help the FHKSC Tigers win their games. The January 24, 1935, issue of the *HDN* reported, "A special telephone hookup direct to his hospital bed from the Coliseum floor carries a running account to Gross who apparently obtains a vivid picture of the games judging from the suggestions he is able to make as the game progresses." Jack Riley, the college football coach, took over the coaching of the basketball team until Gross recovered.

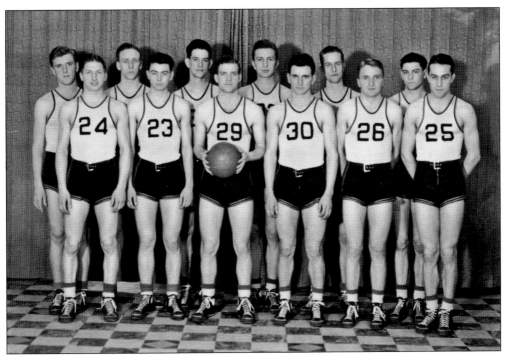

The 1935 FHKSC basketball team was without its coach, as he was stricken at the beginning of the season. The players were coached on the court by Jack Riley, the head football coach, with some help over the telephone from coach Gross. The five-year winning streak of 33 nonconference games ended with this season.

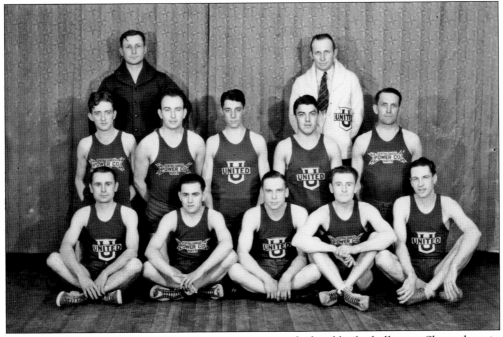

The Central Kansas Power and Gas Company sponsored a local basketball team. Shown here in 1932, the team would play other town teams like the similarly organized baseball teams.

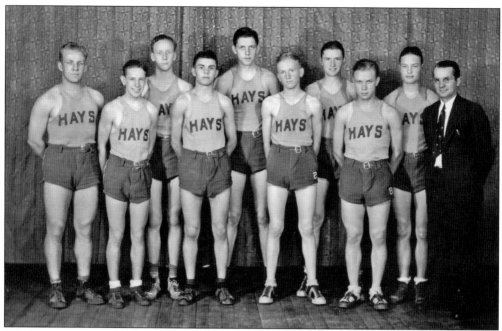

The Hays High basketball team was coached in 1932 by Lew Lane. The team did not have a winning season that year, although it had a "mid-season spurt which has transformed them from a mediocre ball club into a dangerous foe," stated the February 23, 1932, issue of the *HDN*.

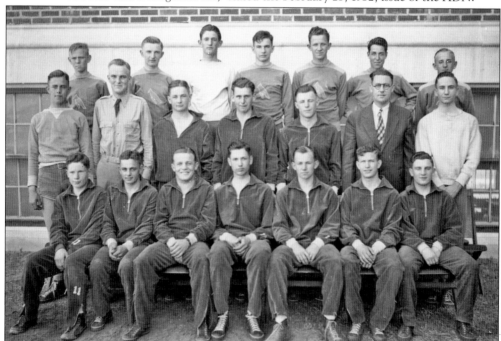

In 1937, the St. Joseph's College basketball team shared the Union Pacific league championship with Hays High School. "Cadet basketeers won 12 of 17 games during the season and played the semifinals in the regional tournament," reported the May 1937 issue of the *Cadet Journal*. Three of the teams were placed on the Union Pacific league all-star team.

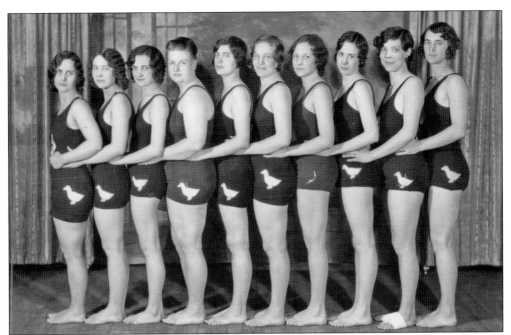

In March 1931, the Duck Club, part of the women's physical education department of FHKSC, presented an unusual entertainment in order to raise money to pay for the club's page in the school yearbook. It was a water festival that included demonstrations of lifesaving, the standard strokes used in swimming, and a presentation of *The Conch Shell*, a play revolving around the daughter of King Neptune.

The swimming pool at Sheridan Coliseum at FHKSC was also used by the town's swimmers. In April 1936, a competition was held in Hays at that pool. There were five events in three age groups. The April 9, 1936, issue of the *HDN* stated, "In the midget division the events will be a 60 feet free-style race, a 60-feet backstroke race, a 240-feet relay, a distance float and a fancy diving contest."

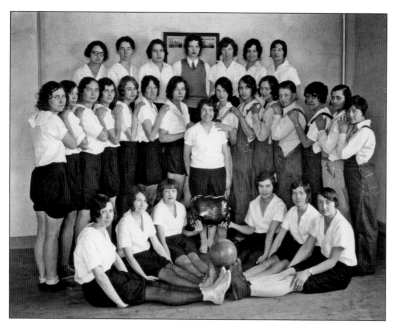

FHKSC women's soccer would alternate with field hockey as the major sport each year. This is the 1930 winning soccer team in the Women's Athletic Association (WAA). Besides the engraved plate, each member of the team received an award designed by Irene Connoran of the department of physical education.

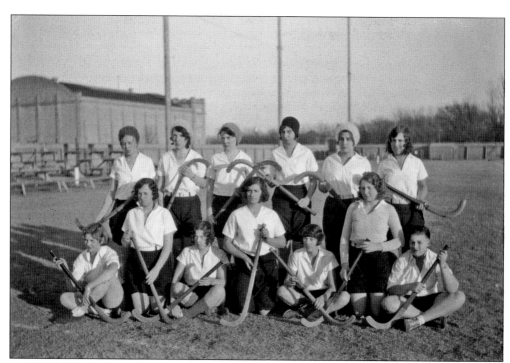

In 1931, field hockey was the major sport in the WAA at FHKSC. There was an annual intramural tournament every fall for the sport and these were the champions for 1931. Pictured from left to right are (front row) Edith Hunsley, Mary Gale Reece, Bernadine Cooper, Mary McNinch, Marie Hoffer, Ida Marie Wickizer, and Myrna Tomlinson; (back row) Frances Hoff, Josephine Farrish, Martha Wylie, Ines Spitznaugle, Loretta Nicholas, and Mildred Franz.

In 1936, the Hays High track team was coached by L. D. Opdycke, known as Uppy, who hoped to add a third Union Pacific league title to his team's record. Not only did the team do well in the league, it also qualified for the state track meet for the first time ever.

The track team from FHKSC, under coach Jim Yeager, traveled to Wichita to compete in the Central Conference track meet in May 1936, where it came up third overall behind Pittsburg and Emporia. In the high hurdles, the team came in first and third.

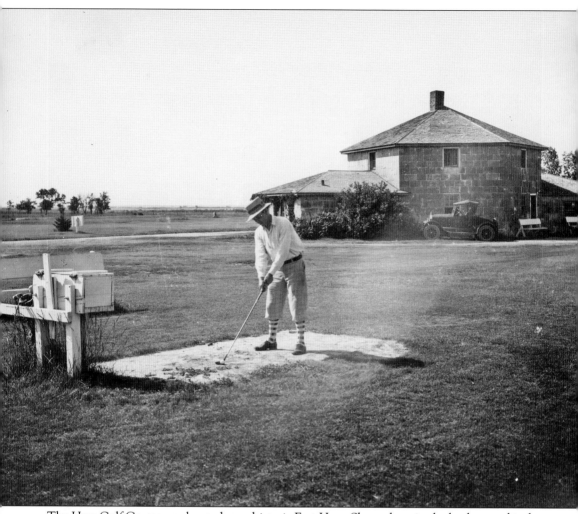

The Hays Golf Course was located near historic Fort Hays. Shown here in the background is the original blockhouse of the fort being used as a clubhouse. The June 7, 1930, issue of the *HDN* related, "A 'tombstone' gold tournament may not have the funeral aspects its title suggests if the plans of the officers of the Hays Golf Club do not go awry. Such a tournament is being planned for June 16 and 17 and officials of the club refuse to make any explanation of the tournament except to say the best players will be rewarded for their efforts with prizes. The play is to be for men only. On June 26, 27 and 28, however, there is to be a Scotch foursome tournament for men and women and prizes are offered for that event also."

Six

STRUCTURES

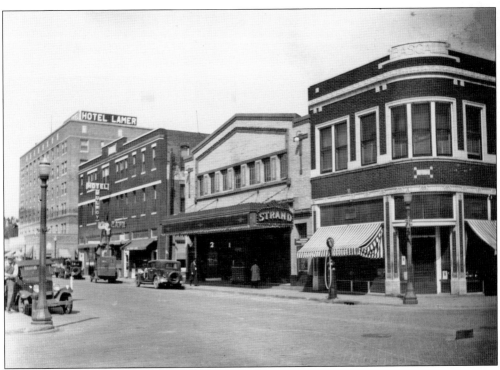

This photograph from June 1933 shows the east side of Main Street looking north from Eleventh Street. The buildings are, from left to right, the Lamer Hotel, built in 1930; the Mulroy Hotel, built in 1889 and remodeled in 1922; the Strand Theater, built in 1917; and the Basgall Grocery Store, built in 1917.

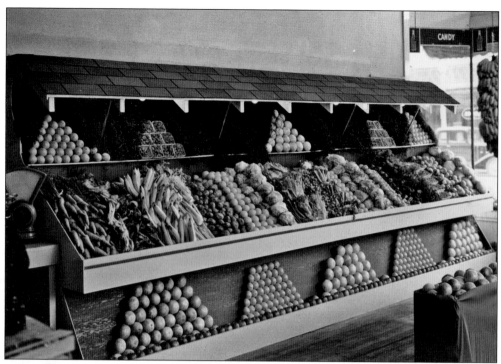

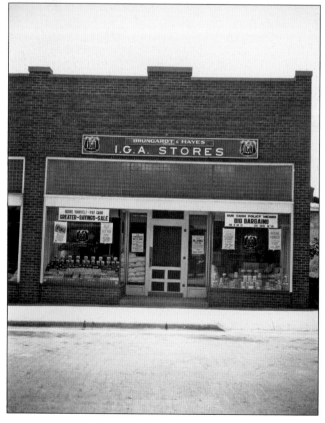

J. B. Basgall built his Basgall grocery store, located at the corner of Eleventh and Main Streets, in 1917 because he needed more room. Basgall began in the business by working for a grocery store owned by A. A. Hoover. In 1899, Basgall bought Hoover's store from him and continued in the grocery business. The interior is shown here in 1937.

July 1930 saw the opening of a new grocery store and meat market in Hays, located at 112 West Eleventh Street. "The business which is to be owned by Mr. Brungardt and Mr. Hayes, is to be operated on the buying plan of the I. G. A. stores. Fixtures for the combination meat and grocery store are expected to arrive the first of next week," reported the June 28, 1930, issue of the *HDN*.

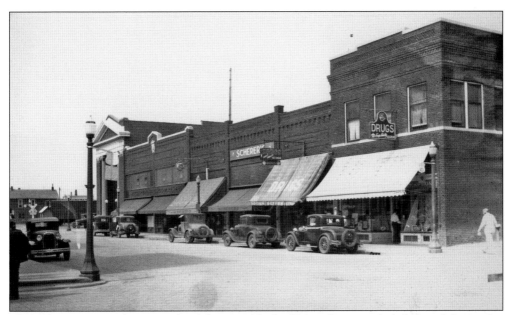

Shown here in 1933, the west side of the 1000 block of Main Street included, from left to right, the First National Bank, J. C. Penney, the A. B. C. drugstore, Scherer's clothing shop, the Geyer Brothers drugstore, and the Hays City drugstore.

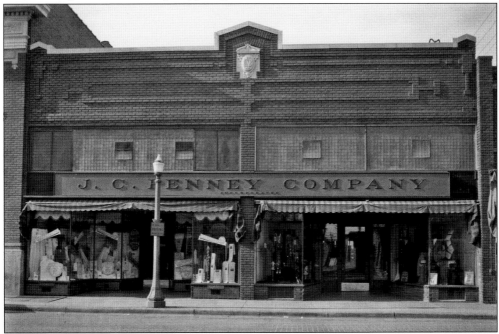

In 1929, the J. R. Byars Company was bought out by the J. C. Penney Company. Located at 1003–1005 Main Street and shown here in 1931, the J. C. Penney store remained downtown until the early 1970s. The Hays store was one of over 100 Byars stores taken over by J. C. Penney. The August 1, 1929, issue of the *ECN* stated, "Mr. W. D. Larkin is manager of the store and he expresses himself as highly pleased with the general improvements which have been made throughout the stock in the store."

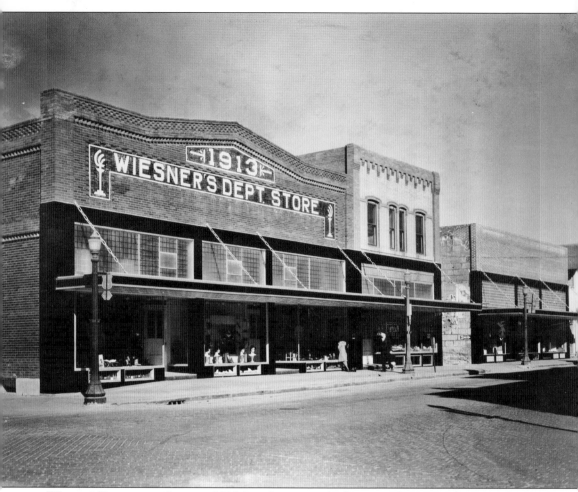

Wiesner's Department Store, at 801 Main Street, was built in 1913 by A. A. Wiesner. By 1937, Wiesner's was the largest department store in western Kansas. In 1936, the November 17, 1937, issue of the *HDN* reported, "An 'off year', he [Wiesner] sold approximately $450,000 worth of merchandise. Now Mr. Wiesner has remodeled the interior of his store . . . and increased his floor space to 22,000 square feet." Wiesner told the news reporter when asked about men trying to go into business in 1937, "Young men who go into business now must know a great deal more than men who went into business in earlier years. The young man of today must know his merchandise." Wiesner's department store closed in 1991.

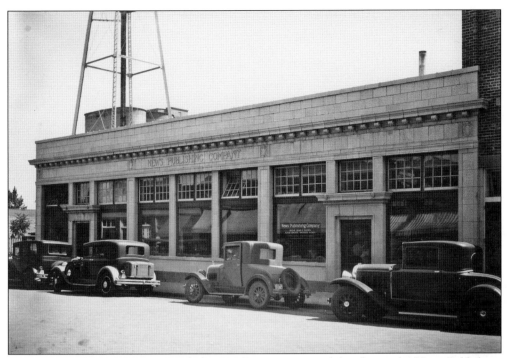

In 1924, the *Ellis County News* and the *Free Press* were consolidated into the News Publishing Company, located at 112 East Eleventh Street. Besides putting out the weekly *Ellis County News*, it began publishing the *Hays Daily News* in 1929, the first daily newspaper in Hays. Within a year, the paid subscriptions went from 500 to 1,700.

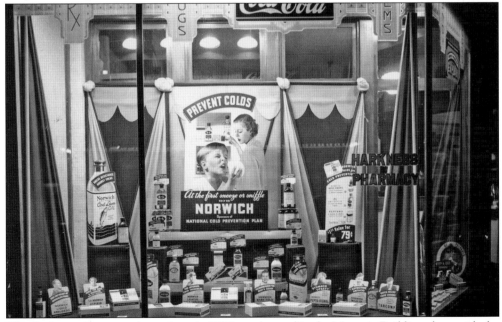

The Harkness drugstore, shown here in 1936, was located in the Masonic Building along with the Grass Brothers Grocery Store. The next year saw Duckwall's moving into the building and C. A. Harkness moving his drugstore to 716 Main Street just south of the Farmers State Bank.

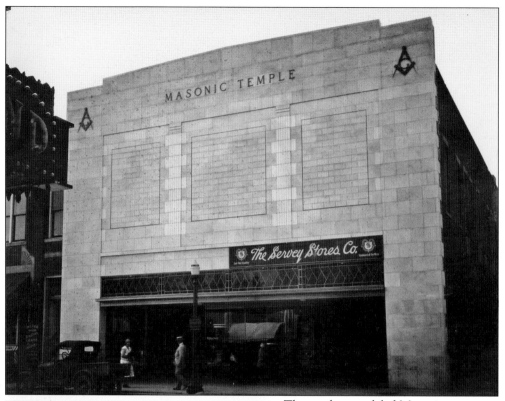

The newly remodeled Masonic Temple, at 1105 Main Street, opened on April 2, 1930, to a crowd of 200. The building received a new front of Carthage stone and new rooms on the second floor where the Masonic Hall was located. The Servey Stores Company occupied part of the lower level and opened its women's wear store at the same time. Various stores would occupy the lower level over the years.

In March 1932, the Duckwall Company opened a store in Hays. It was originally housed in the Felten Building at 107 West Eleventh Street, shown here in 1936 promoting Easter. Duckwall's would move to the Masonic Building in 1937. The Masonic Building, including Duckwall's, was destroyed by a fire in 1943.

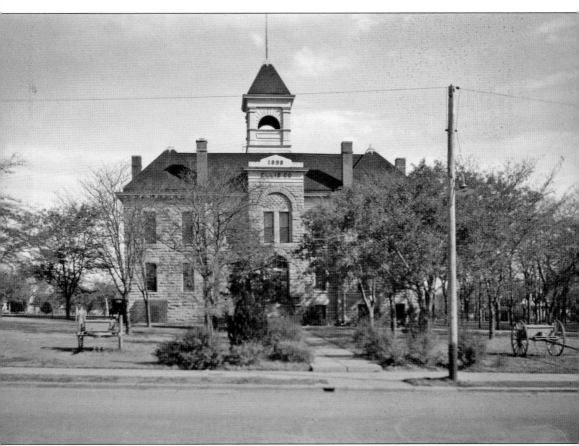

Ellis County had problems with her early courthouses. They seemed to burn down with great frequency. This is the fourth courthouse, built in 1898 and shown here in 1933. The October 25, 1933, issue of the *HDN* reported, "Business has been brisk at the office of Ben Huser, county clerk in the hunting license department, especially since the hunting season opened. Two hundred fifty hunting licenses have been sold in the county." In 1940, a special election was held "for the purpose of voting on the issuance of $88,000 in bonds to be augmented by a $158,000 grant from the federal government, for the construction of an Ellis county courthouse," stated the May 29, 1940, issue of the *HDN*. The building pictured here was torn down in 1942 when the present courthouse was built.

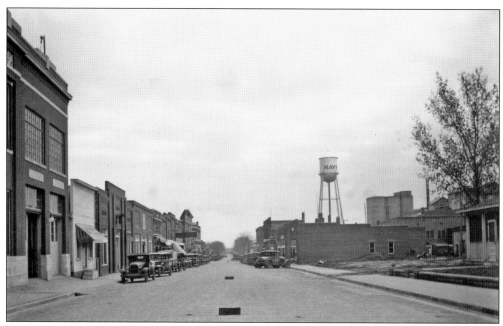

Pictured above is West Eleventh Street looking east from Fort Street in 1933. Businesses on this block included stores such as the Sweetbriar Shop, Czeskleba Music, and Quality Bakery. There were also professional offices such as the McCarthy law office, and Dr. C. F. Bice, osteopath. The building to the above left is pictured below in 1934 and was a combination city hall, police department, and fire department. The September 13, 1934, issue of the *ECN* related, "From now on if you get into trouble with the city law enforcement officers, there will be some consolation. At least you can ride to the 'hoose-gow' in style. For the city has replaced the old police car with a shiny new Ford two-door sedan." City hall and the fire department remained in this location until March 1974, when they moved to Sixteenth and Main Streets.

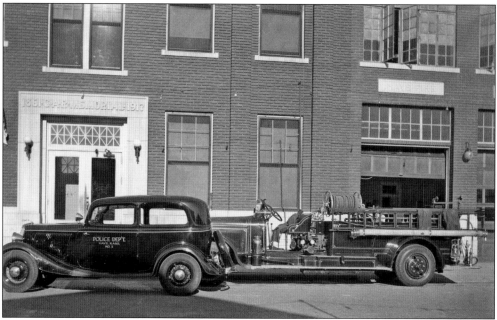

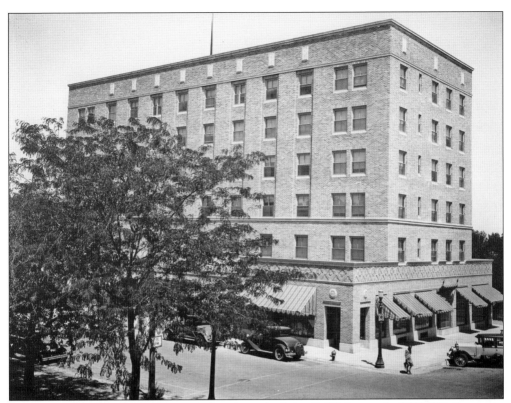

The Lamer Hotel opened in June 1930 and was built by C. W. Lamer for $300,000. It was six stories high and had 100 rooms. "Hays will celebrate the opening of the Lamer Monday. There will be a program of boxing bouts to be staged by the American Legion, band concerts and a pavement dance at night will be a feature. Many visitors are expected from neighboring towns and the fifty persons on the Lamer staff will be on 'dress-parade' all day to make them feel at home and to show them through the building," reported the June 14, 1930, issue of the *HDN*. Located at Twelfth and Main Streets, the first floor of the hotel included shops of various types, such as the Lamer Café and the Lamer drugstore pictured below.

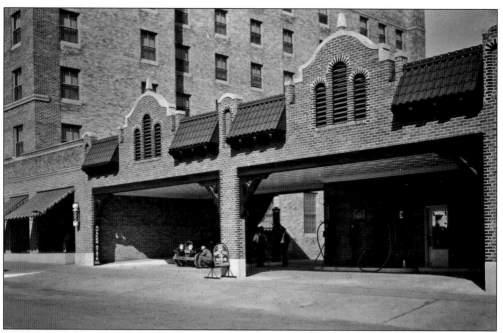

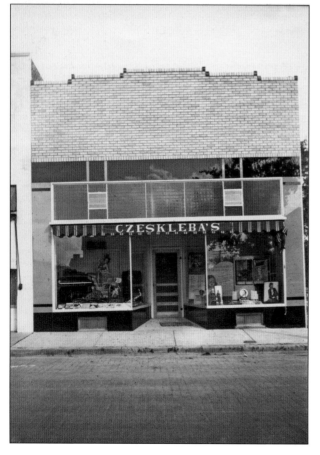

On November 15, 1930, the Kent Oil Company Super Service Station had its grand opening. Located at 105 East Twelfth Street, the station adjoined the Lamer Hotel. W. H. Dixon operated the station, which included services such as car washing, electric car polishing, power greasing, and tire repair.

In August 1938, the Czeskleba's Music Company moved from its location on Eleventh Street to this location at 714 Main Street. Besides owning the music store, Dr. William Czeskleba was also an optometrist, whose office was located above the store.

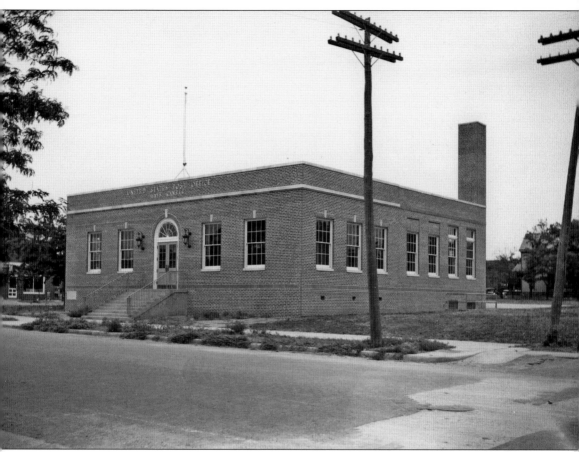

In 1931, according to the February 27, 1931, issue of the *HDN*, "Word came over the wire of the Associated Press that Hays is to share in the emergency relief appropriation of Congress with an appropriation of $100,000 for a new federal building." The federal building it was referring to was the Hays Post Office, shown here in August 1935 shortly before opening. The post office committee consisted of W. H. Lewis, H. W. Chittenden, and C. W. Reeder and had been advocating for a new building for several years when word of the funding came through. A site was chosen and acquired in 1933 and construction began in January 1935.

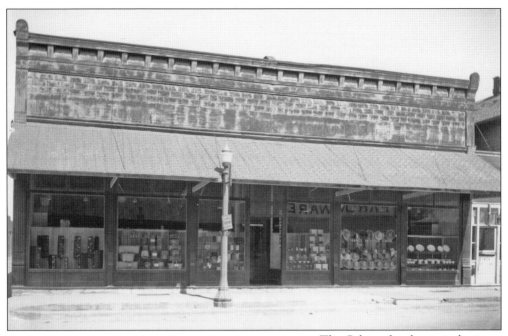

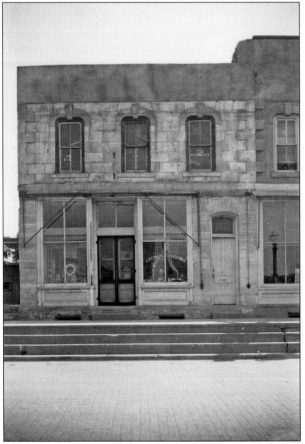

The Oshant family was in business in Hays for nearly 100 years. Henry Oshant, followed by his son Fred, owned several different businesses over the years. One of the locations of the Oshant Variety Store was at 807 Main Street, shown above in 1936. After Henry's death in 1935, Fred continued the business, eventually selling this building to A. A. Wiesner in 1937 and moving the store to 129 West Tenth Street, seen at left, in 1936. One of the other businesses Henry Oshant owned was an abstract real estate and insurance office located at the Tenth Street building. J. F. Costner rented the lower space for his Electric Shop. Fred Oshant continued in business at the Tenth Street location, first as the Oshant Variety Store, then as an ice cream and confectionery business, and then in 1947 as the Army and Navy Store. It closed in 1972.

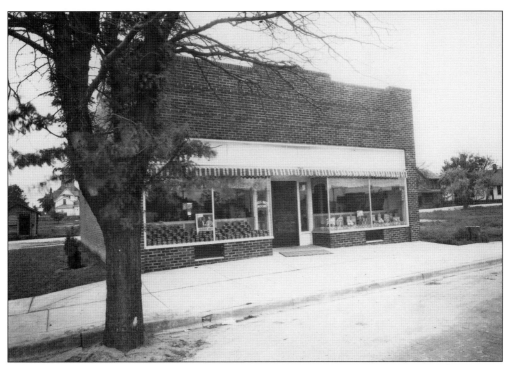

The Grass family had a long tradition in the grocery business. George Grass started a store in 1890. His sons took over the business and started the Grass Brothers Grocery in 1920. The store was located in the Masonic Building for many years, and in 1937 the brothers announced they were building a new, modern food market at the northeast corner of Tenth and Ash Streets, shown here in 1938. Besides having both new, up-to-date meat cases and vegetable displays, there was plenty of parking available.

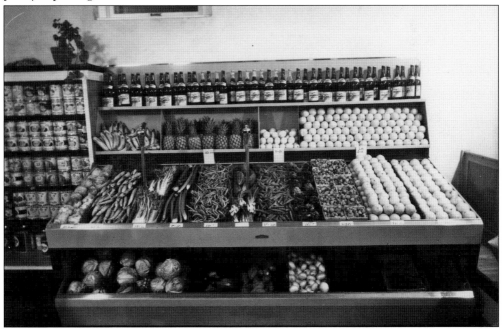

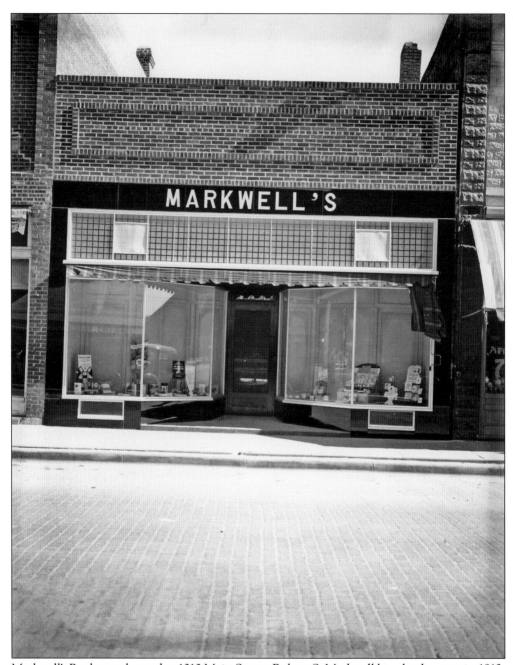

Markwell's Books was located at 1010 Main Street. Robert S. Markwell bought the store in 1912, and it closed in the early 1970s. The store is shown here in 1936 after the front had been remodeled the year before with "a new front of black glass and black carara. . . . The front is to have a recessed entrance with large glass display windows on either side. There will be black glass base trimming and the space above the windows will be of the black glass into which the name of the store is to be sandblasted. The front is to be one of the most modern in the downtown district, Tony Jacobs, the contractor, said," reported the August 1, 1935, issue of the *ECN*.

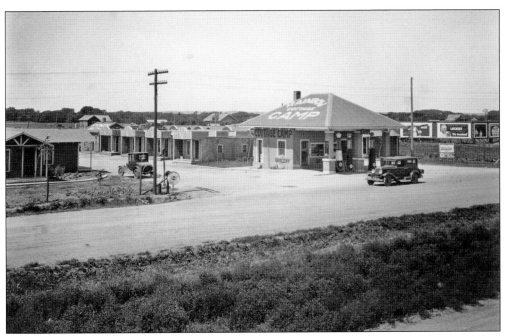

A precursor to the modern motel, the cottage camp became more and more popular in the late 1920s and the 1930s as people traveled more on the open road. By 1929, more than 5,000 people had spent the night at a cottage camp in Hays. The Rainbow Cottage Camp, located on East Eighth Street, was owned by E. W. Mann. It opened the summer of 1929, and by 1930 (shown above) the camp had added more cabins as well as space for campers with their own tents. The Thomas Station and Cabin Camp was located at 100 East Fifth Street and was owned by R. B. Thomas. Shown below in 1934, the Thomas Camp also had tenting space. In 1935, it would add another six cabins at a cost of $12,000.

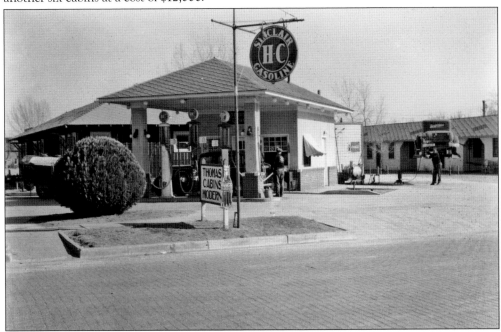

H. W. Twenter moved from Hutchinson in 1928 to start up the Twenter Motors Ford dealership. The August 30, 1928, issue of the *ECN* stated, "Mr. Twenter has bought the Oldham garage and salesroom building, a brick structure, at the southeast corner of Juniata [8th Street] and Oak Streets and has taken possession." It is shown here in 1931.

O'Loughlin Motors, located at 126 West Twelfth Street, had been a Ford dealership for nearly 20 years when, in 1928, it became a Chevrolet dealer. John O'Loughlin owned the business until his death in 1933, when his son Joseph took over. The dealership is shown here in 1936.

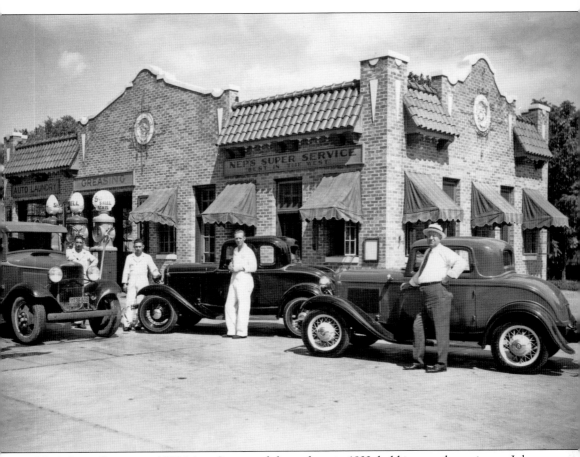

Nep's Super Service, at 1300 Main Street and shown here in 1932, held its grand opening on July 3, 1931. According to the July 2, 1931, issue of the *ECN*, part of the "opening Frolic" included "a gala open-air dance on the plaza surrounding the new station," featuring Hal Pratt and his 12-piece band. By 1936, the L. J. Jacobs Oil Company owned a chain of 13 Nep's Super Service stations located at Plainville, Stockton, Collyer, Wakeeney, Ogallah, Ellis, Yocemento, Hays, Victoria, Gorham, and Walker. "This company which began operations here only a few years ago has experienced a phenomenal growth of business," reported the October 29, 1936, issue of the *ECN*.

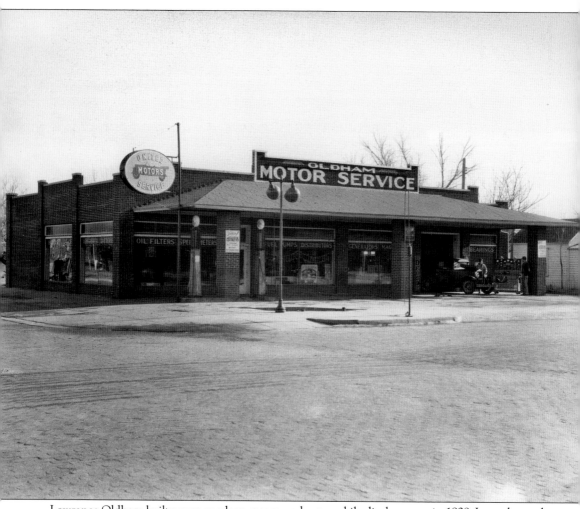

Lawrence Oldham built a new, modern garage and automobile display room in 1929. It was located at 1108 Oak Street. Shown here in 1933, Oldham Motors was the Oldsmobile agency in the area. The Oldham Brothers garage was previously located at the corner of Oak and Eighth Streets. In 1928, the agency sold that building to H. W. Twenter, who started Twenter Motors there.

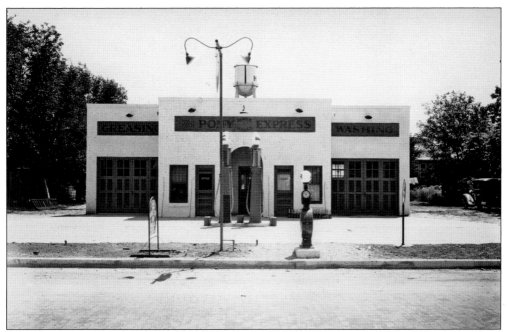

Fred G. Pomeroy opened the Pony Express Super Service Station in May 1930. Located on East Thirteenth Street between Oak and Main Streets, next to the Lamer Hotel, the station offered a parking area free to guests of the hotel. In 1936, Ben Dreiling took over this location and built onto it for his car dealership.

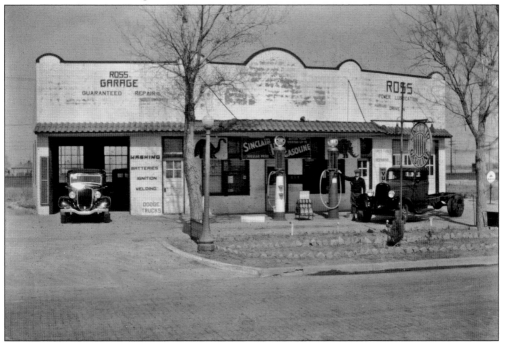

In 1930, George Ross moved back to Hays from Texas and built a super service station located at 527 East Eighth Street. Shown here in 1934, the Ross Garage was of Spanish-style architecture. Eventually it would add matching cabins and would be known as the Ross Courts.

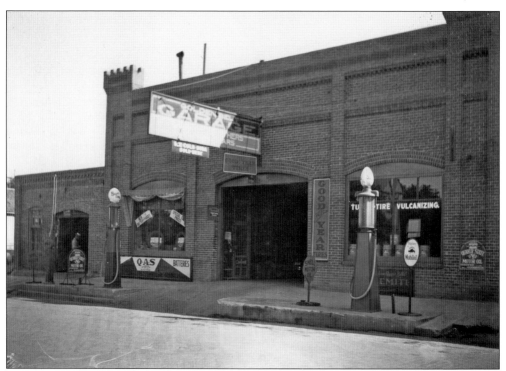

The Golden Belt Garage was located at 111 West Eighth Street. Owned by John R. Staab, the business specialized in Goodyear tires and servicing Dodge vehicles. Shown here in 1931, the garage closed later that year.

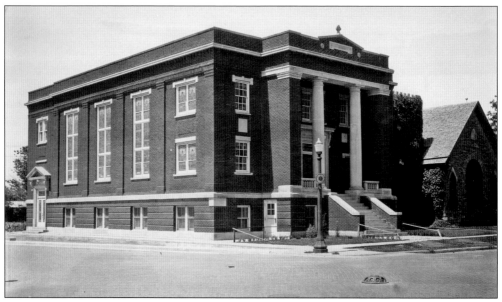

The First Presbyterian Church congregation built a stone church in 1879. The structure pictured here in 1930 was built adjacent to the stone church and was dedicated in 1926. The congregation continued to meet in this building until the 1970s. It presently houses the Ellis County Historical Society.

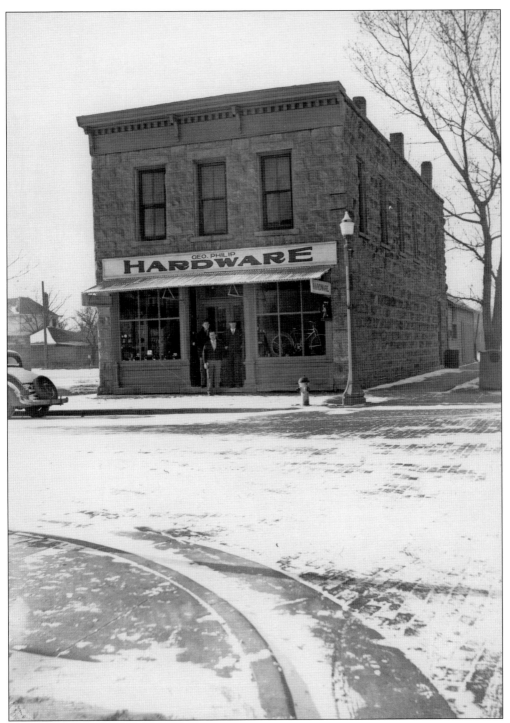

The Philip Hardware store was part of the original British colony located in Victoria, Kansas. In 1894, the Philip family moved the store to Hays, and in 1896 they relocated it to 719 Main Street. Founded by George Philip II, the hardware store stayed in the family for four generations, ending with George Philip V closing it in 1997. It is shown here in 1936.

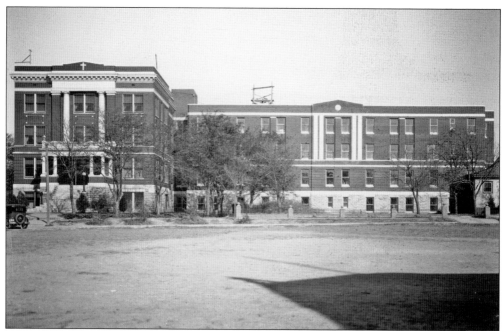

St. Anthony's Hospital, located at Thirteenth and Ash Streets, was built in 1916. A large wing was added, shown here in 1930. Another addition was added in 1933 that included "two sun porches and an open-air ward for use of the crippled children," reported the November 23, 1933, issue of the *ECN*. The hospital moved to its present location on Canterbury Drive in 1972.

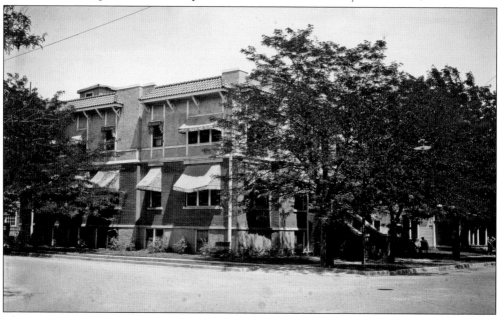

The Hays Protestant Hospital, at 207 West Seventh Street, shown here in 1930, was dedicated June 18, 1925. The new hospital was sponsored by the Northwest Kansas Conference of the Methodist Church and supported by all of the Protestant denominations. According to the June 18, 1925, issue of the *ECN*, "The physicians and surgeons of Hays are making themselves equally at home in both local hospitals."

St. Michael's Episcopal Church was consecrated in 1911. Referred to as the Treat Memorial, Marcus J. R. and Cordelia Treat donated the land and money for the construction and maintenance of the church. It was located on the corner of 12th and Fort Streets until destroyed by fire in 1965.

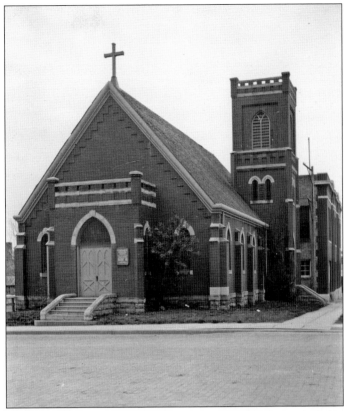

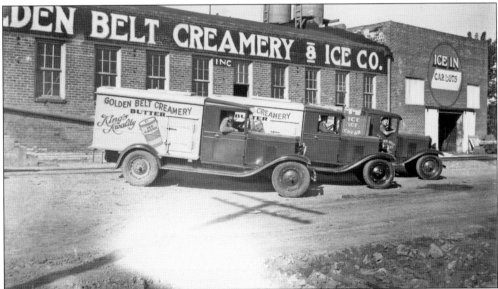

Harry Felten originally owned the Hays Creamery and Ice Company. It was then sold to the King brothers, who named it the K. K. K. Ice Company. In 1921, Jacob Brull teamed up with the brothers and it became the Golden Belt Creamery and Ice Company, located at 310 East Eleventh Street, shown here in 1930. Brull bought the business outright from the King brothers in 1938 and renamed it the Hays Creamery and Ice Company.

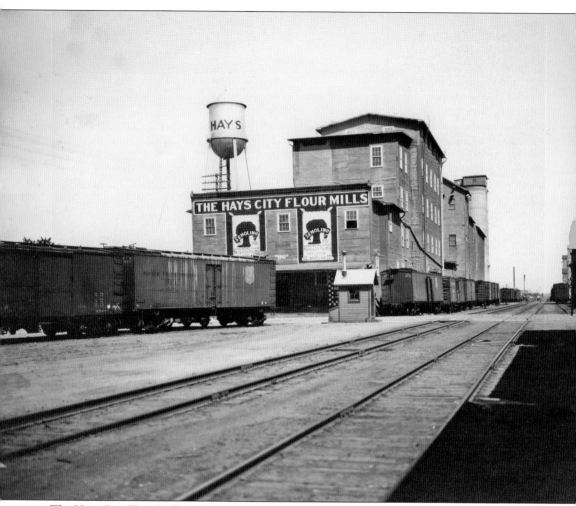

The Hays City Flour Mill, built in 1908 and shown here in 1930, was located at 902 Main Street. I. M. Yost had built other mills on that site, but they all burned down. In 1906, he sold to the Colorado Milling and Elevator Company of Denver, who continued to own it until it closed in 1962. It was torn down in 1982. The mill was known for the semolina flour it produced.

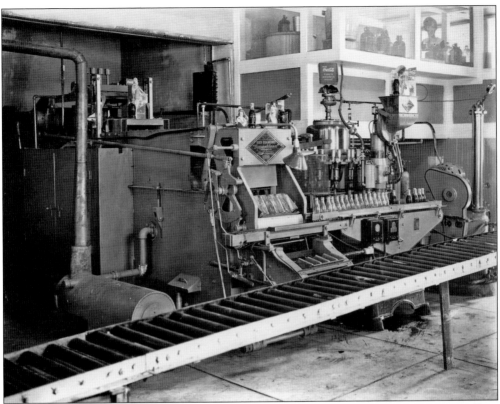

The original building at 201 East Twelfth Street was constructed in 1918 as the Hays Bottling Works. It became Coca-Cola Bottling in 1925. In 1929, manager Peter Jacobs doubled his floor space at the plant with a brick addition. In 1936, the company built an addition "to be used as a warehouse and to house trucks," reported the September 10, 1936, issue of the *ECN*. Coca-Cola Bottling remained on this site until 1976. The picture above is from 1930 and the one below from 1936.

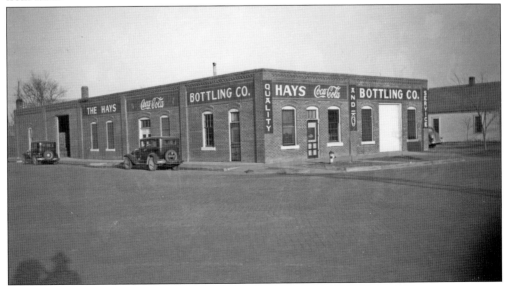

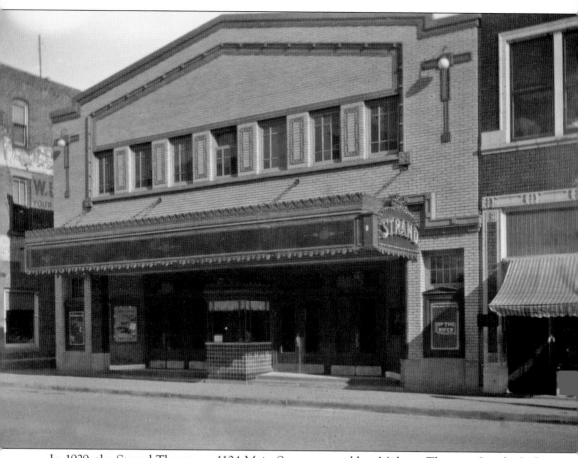

In 1929, the Strand Theater, at 1104 Main Street, was sold to Midwest Theaters, Inc. by J. G. Kirkman, who had operated the theater since it was built in 1916. It continued as a movie theater until the 1950s. Shown here in 1930 after the theater was remodeled, the September 5, 1929, issue of the *ECN* stated it was to include "an electrically lighted Marquise . . . over the entrances, a large foyer will be available just within and a new box office has been constructed." The various changes to the theater cost $14,000. "One feature, especially, which will lend a metropolitan touch to the theatre, is a 'traveler.' A traveler is a luxurious plush curtain drop on which the picture is first flashed. Showing here for an instant only, the traveler parts in the middle and the picture proceeds on the screen," reported the August 22, 1929, issue of the *ECN*.

Seven

WORKING

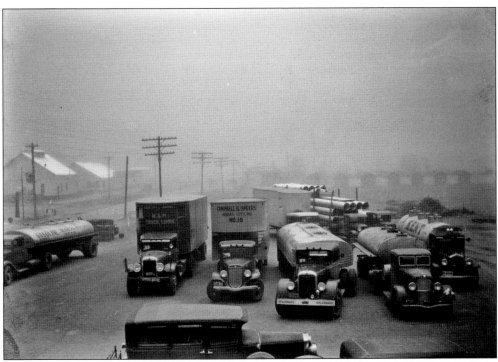

The dust storms during April 1935 were the worst of the dustbowl period. While the storms obviously wreaked havoc with agriculture, they also affected other types of work. Here on April 10, 1935, U.S. 40 is at a standstill with the drivers of trucks and cars no longer able to see. These trucks, with their valuable loads, were going nowhere. According to the April 10 issue of the *HDN*, "Motorists were warned to make no attempt to travel west of Hays this afternoon as the dust storm reduced visibility to a few feet."

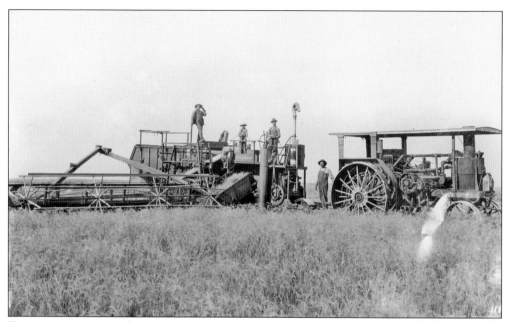

Farming was very much a way of life and an extremely important industry in the area. The 1930s brought new challenges to this industry. In the early part of the decade, too much wheat was produced, driving prices down; later the fields were dust and not producing much at all. The Wheat Farming Company of Hays (pictured) was organized on February 3, 1927, by a state charter for the purposes of "encouragement of agriculture for profit," stated the June 10, 1933, issue of the *HDN*. By 1933, it owned and farmed "64,000 acres of land in western Kansas and sold stock amounting to $2,728,418 to more than 1,200 stockholders of which more than 70 per cent are farmers." In 1933, the Supreme Court of Kansas ruled that such corporations as the Wheat Farming Company were not authorized to "engage principally in conducting farming operations for profit." The suit was brought against these types of corporations because of the fear that they were "replacing individual farmers and depopulating the state."

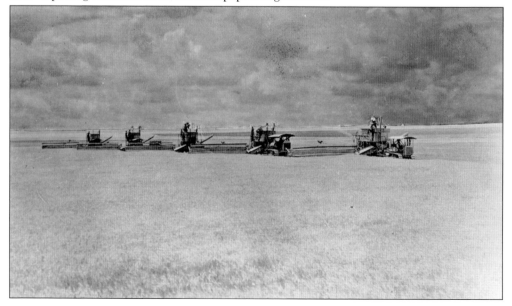

With farming a major industry in the area, farm equipment also played a role in local business. Several businesses sold farm machinery, including Hays Tractor and Equipment and N. F. Arnhold and Sons.

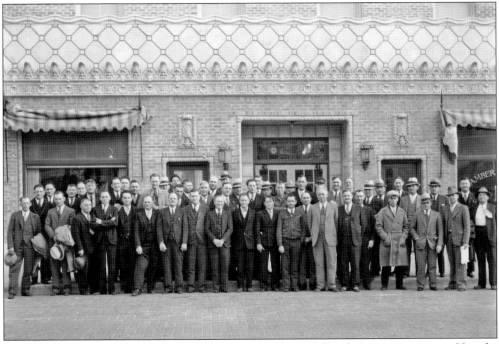

In March 1934, members of the Northwest Kansas Highway Officials Association met in Hays for their annual spring meeting. The March 15, 1934, issue of the *ECN* related, "County engineers, county clerks and county commissioners were in attendance as well as a number of material and supply company representatives." The attendees are shown here in front of the chamber of commerce office located in the Lamer Hotel.

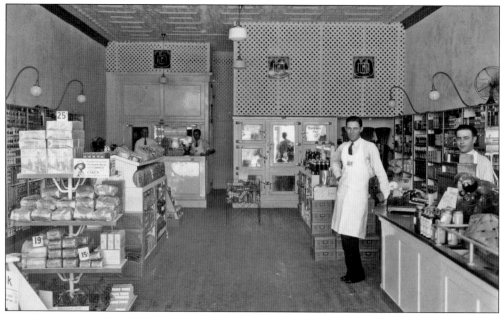

It is July 18, 1930, and the new IGA is ready to open its doors. Leland Hayes and Tony Brungardt were the owners of the new store located on West Eleventh Street. While Brungardt had experience in the grocery field, as he had been the manager of the local Piggly Wiggly store, Hayes was new to the business. Previously Hayes had been employed by the United Telephone Company.

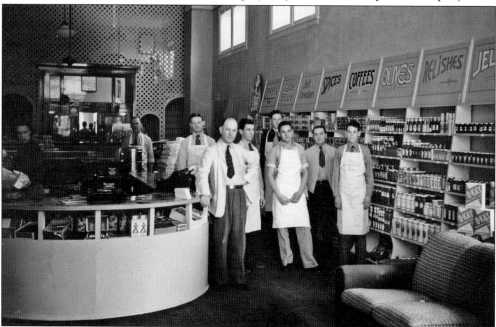

J. B. Basgall built this grocery store in 1917, which is shown here in 1937. Basgall began his career delivering groceries for A. A. Hoover's grocery, eventually buying out Hoover. The Basgall store was a family-run business that was "not only a place of business but also a social center and a general gathering place for the countless customers and friends he has the knack of making and keeping," stated the May 29,1949, issue of the *HDN*.

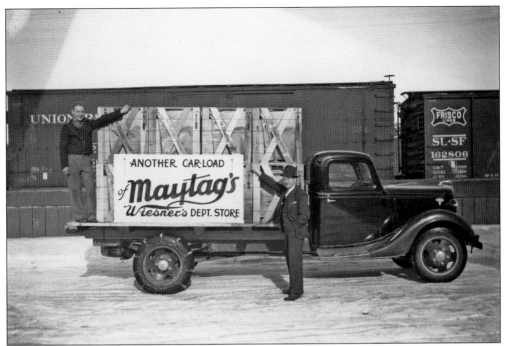

Wiesner's Department Store had been in business for 39 years when, in 1937, the store expanded and an appliance store was added. The appliance store was located next to the department store at 807 Main Street, pictured below in 1939. Wiesner's was a family business with six sons working there. Son Frank, who was the manager of the appliance store, began his career as a delivery boy for the grocery store.

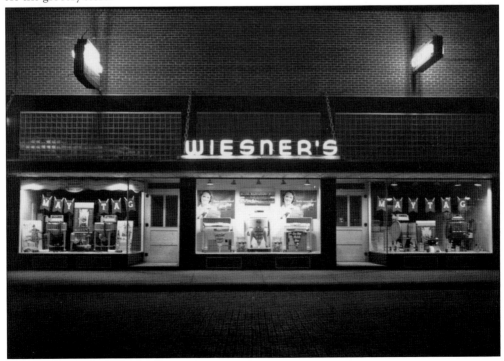

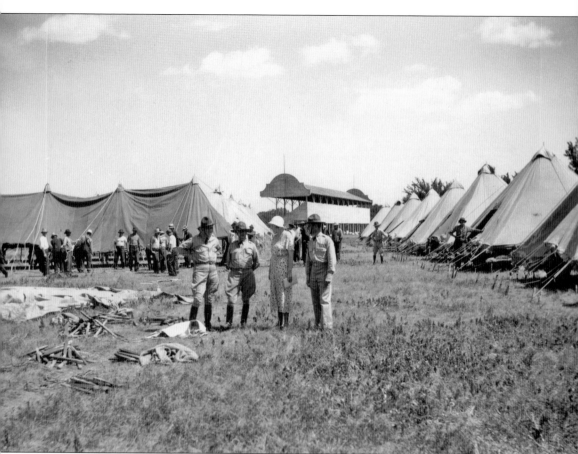

In 1933, Hays was selected as a site for a Civilian Conservation Corps (CCC) camp. This was one of six Kansas camps, and its arrival in Hays was very much due to the efforts of Congresswoman Kathryn O'Loughlin McCarthy, pictured here with the camp's officers. Hays having the camp meant "the expenditure of more than $100,000 here in the next six months and vast improvements to 7,600 acres of state land on which are located the Fort Hays State College, the Fort Hays Experiment Station, and Hays Frontier Park. . . . The camp will be located on the old fair grounds, where recreational and living facilities are to be established," reported the July 20, 1933, issue of the *HDN*. In October, the workers moved out of the tents into barracks that had been constructed from buildings in the abandoned Golden Belt Fair.

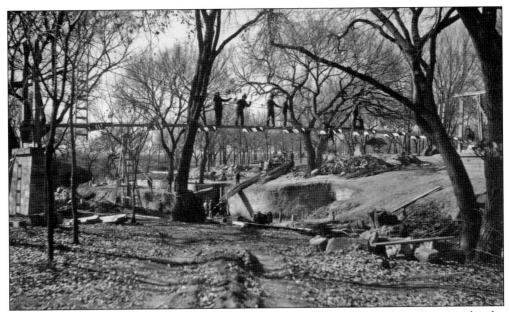

The conservation program that the CCC inaugurated in Hays was the first project under the Department of the Interior in Kansas. Other projects had been under the forest service in the Department of Agriculture. The projects the corps worked on while located in Hays included improvements to roads, new road construction, and the building of three dams and two swinging bridges. Improvements to the state park also took place. The June 21, 1934, issue of the *HDN* reported, "The clearing of the creek bed, the building of tables, of ovens, shelter houses, and rustic seats have made the park a desirable picnic spot." Pictured above is the swinging bridge in Frontier Park being built, and below is one of the dams built on Big Creek.

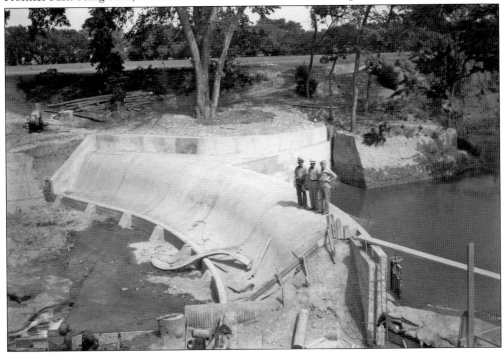

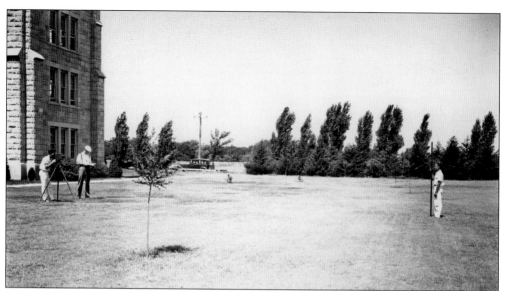

During President Lewis's administration, FHKSC took on a new look along with its new name. Several new buildings were constructed, and the grounds were given new attention. The surveyors pictured above and the grounds crew pictured below were both important components to Lewis's vision. According to Wooster's History, "A drive around the campus was constructed making of it a quadrangle. . . . Grass, flower beds and shrubs were added, and in the last year of his administration President Lewis planned and had constructed an outdoor amphitheater and rock garden. This made the campus an oasis on the plains."

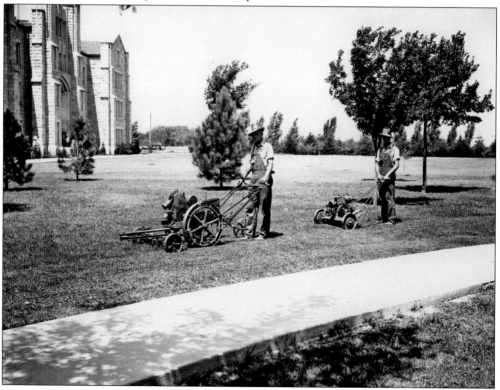

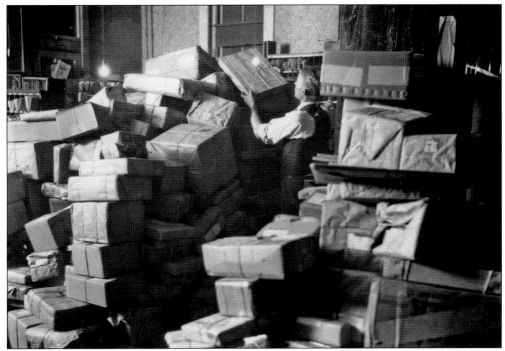

Christmastime is usually joyous, but it was not so for Hays postal workers on December 22, 1930. "The largest volume of mail to be received in one day at the Hays post office in its history, was distributed Monday, December 22, by the postal employees," stated the January 1, 1931, issue of the *ECN*. On that day, more than 13,000 letters and 350 sacks of parcel post were handled. Seen here are the sorting of packages after being stacked to the ceiling and filling the rooms. Postmaster H. W. Chittenden said that he had been so busy with the holiday postal rush that a full account of the volume of business done would take a few more days to figure out.

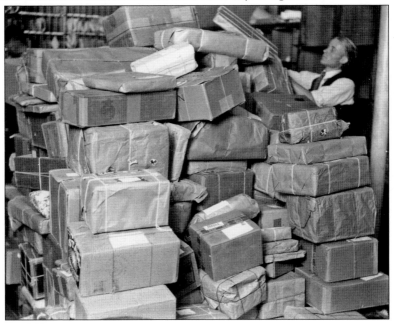

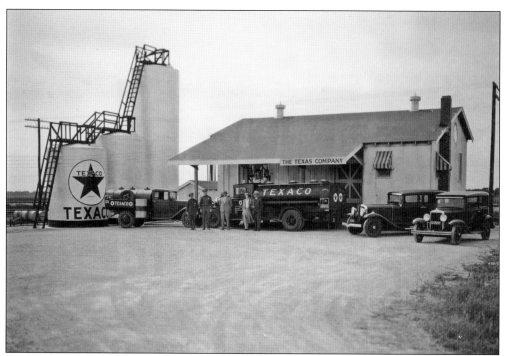

While oil production started in the late 1920s in Ellis County, the 1930s saw that production grow significantly. Above, the Texas Oil Company photograph is from 1931, and the oil field pictured below in 1936 belonged to Leiker Oil. Oil production in 1931 in Ellis County was 198,251 barrels, production in 1936 was 758,152 barrels, and by the end of the next year it had jumped to 4,528,882 barrels (KSGS). The income and new jobs created by the oil industry helped offset the economic problems related to agriculture in the county. In 1936, seventy-nine new families moved to Hays. According to the April 1, 1936, issue of the *HDN*, "A large number of the 'newcomers' are brought here by the oil activity, and are connected with oil companies and lumber and supply houses."

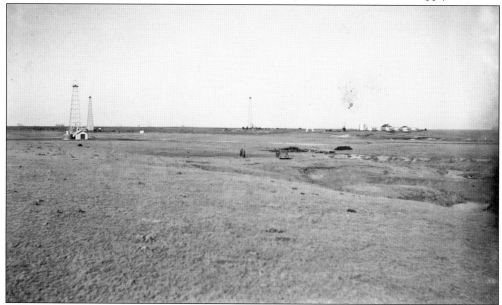

While wheat farming was the leading agricultural mainstay in the area, cattle were also part of the mix. Cattle production remained steady for most of the decade, dropping off toward the end, with 22,983 in 1930, 33,510 in 1934 (the year of this photograph), and 18,700 in 1940.

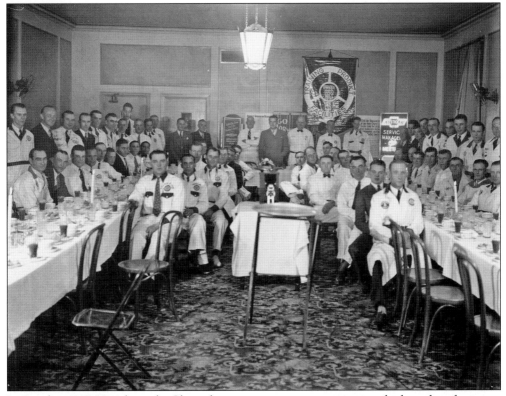

In October 1937, Hays hosted a Chevrolet service managers meeting in which workers from area Chevrolet dealerships/garages learned about the new models about to be introduced the next month and how to take care of them.

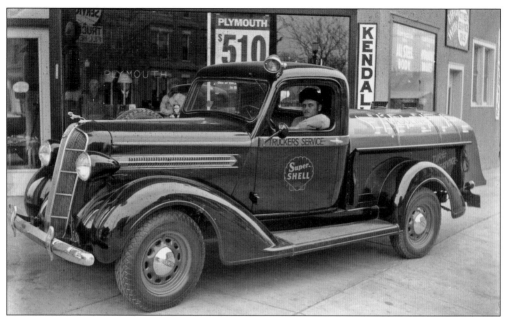

In 1936, the J. R. Schmidt Motor Company was located at Seventh and Main Streets. Besides selling Plymouth cars, it also had a truck service with Shell Oil. The next year, it became the official highway patrol inspection station. "We will start to inspect cars tomorrow morning, September 10, at 8 o'clock and will continue to make daily inspections from 8 a.m. until 9 p.m.," related the September 9, 1937, issue of the *HDN*.

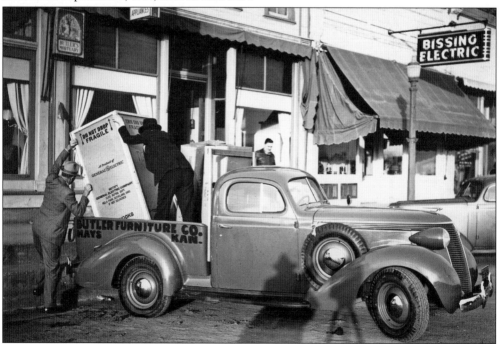

The Butler Furniture and Mortuary business was located at 119–121 West Tenth Street in 1937. Here workers are unloading a new General Electric appliance for the store. In the foreground is the shadow of photographer R. E. Ekey, with his camera and tripod, taking the photograph.

120

The Engel Electric Hatchery, located at 107 West Fifth Street, was owned by C. A. Engel. It was a family business, as is evidenced by two of Engel's children in this picture from 1937. According to the January 28, 1937, issue of the *ECN*, Engel's chicks were from "registered Purina-fed flocks. In every way, they are better chicks . . . larger, stronger, fluffier, livelier, and have a better chance to live. . . . We've taken the gamble out of chick buying. Now, you can raise more of the chicks you start with, because vigor and livability was 'fed' into them."

The United Telephone Company was a large employer in 1930. Employees often had meetings to discuss "interim campaigns" or topics such as "Safety First." These meetings were then followed either by refreshments or, in the case of July's meeting, "the group adjourned to the Golden Glo Greens to play miniature golf," reported the July 17, 1930, issue of the *HDN*.

The Lamer Hotel opened in June 1930 with a staff of 50, including housekeeping, bell captains, laundry, and a chef and waitresses for the café. The June 14, 1930, issue of the *HDN* stated that most of the staff was hired young, "under thirty years of age . . . in commenting on this unusual circumstance, Mr. Lamer believed in manning his hotels with young people giving them the chance to advance in the organization."

The Bissing Brothers Cleaners had been part of Hays since 1916 with "eighteen years cleaning and pressing experience right here in Hays," stated the October 11, 1934, issue of the *Leader*. Shown here in 1933, the business at that time was located in the Lamer Hotel at the corner of Twelfth and Main Streets. It would later move to 118 West Eleventh Street. It was truly a family business, with brothers Frank, Joe, Richard, and Clem working there at one time or another and sister Leona as the bookkeeper. Clem still owned the business when he died in 1976. Brother Charles owned the competing Master Cleaners.

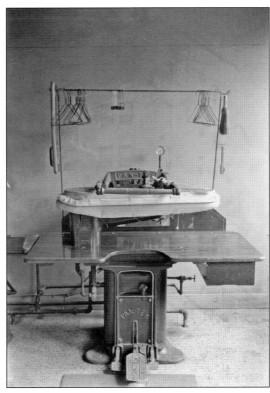

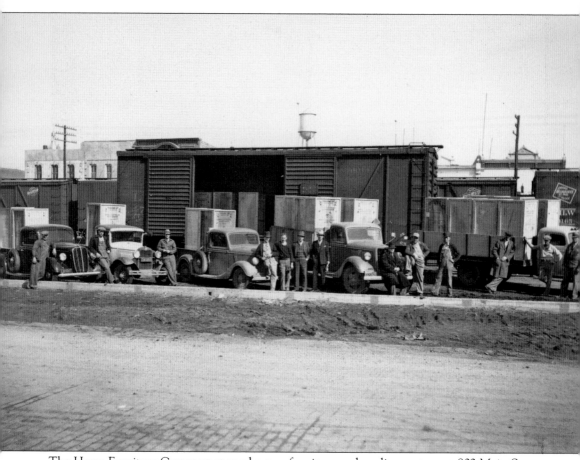

The Home Furniture Company opened a new furniture and appliance store at 802 Main Street on March 1, 1932. The manager was George Gottschalk. As related in the February 25, 1932, issue of the *ECN*, "A complete line of furniture is being stocked and Mr. Gottschalk said today he would carry in addition to varnishes, floor coverings and furnishings for the home." Shown here in 1937, workers load up appliances delivered to Hays for the store that was a dealer in Westinghouse appliances.

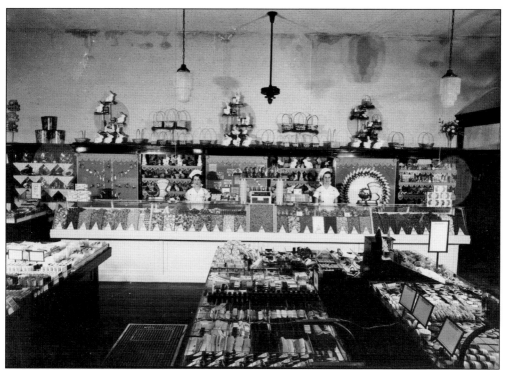

A. L. Duckwall of Abilene opened a store in Hays in March 1932. It was located at 107 West Eleventh Street. "C. E. Masters of Council Grove . . . will be the manager. Mr. Duckwall said he expected to employ Hays persons for clerks," reported the March 3, 1932, issue of the *ECN*. Duckswalls is shown here in 1936 as it prepares for the Easter holiday.

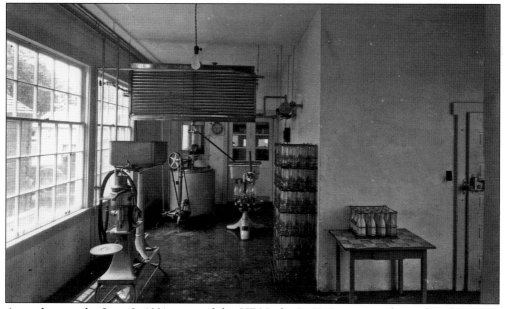

According to the June 2, 1931, issue of the *HDN*, the L. K. Dairy was "located at their new, modern, sanitary plant at 312 East 9th Street" and was "Hays' largest dairy, distributors of raw and pasteurized milk and cream." It was run by J. E. Lowe and Richard Keberlein.

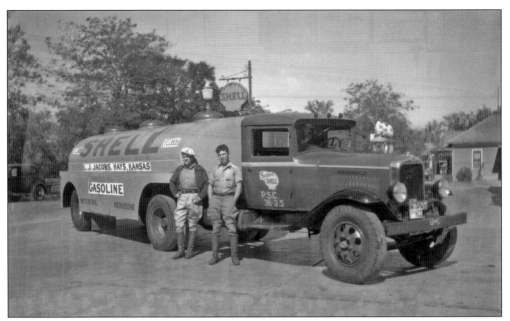

The Jacobs Oil Company owned numerous service stations in the 1930s. It also had its own trucks to deliver Shell gasoline to member stations. Here the delivery drivers stand next to their truck at one of the stations in 1933.

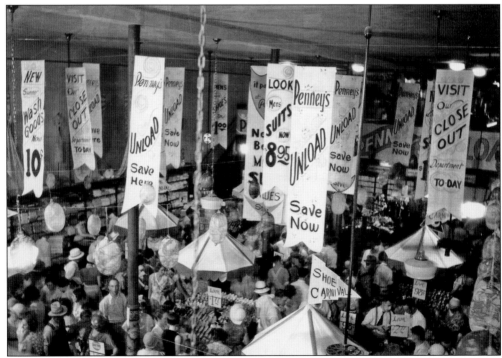

The crowds keep the clerks of the J. C. Penney store busy during a big sale in July 1933. It was the "last chance to take advantage of the dozens of bargains in our ready-to-wear department," including spring hats for 19¢ and "ladies' spring and summer novelty footwear for 97 cents, while they last," related the July 13, 1933, issue of the *HDN*.

BIBLIOGRAPHY

Biennial Report of the Kansas Board of Agriculture. Topeka, KS: Kansas State Board of Agriculture, 1940.

Ellis County News. Hays, KS: News Publishing.

"Graham Family again big noise at Horse Show." *Chicago Daily Tribune*. December 7, 1939: 1.

Hays Daily News. Hays, KS: News Publishing.

Oil and Gas Production in Kansas. Lawrence, KS: Kansas Geological Survey.

Reveille. Hays, KS: Fort Hays Kansas State College.

State College Leader. Hays, KS: Fort Hays Kansas State College.

St. Joseph's Cadet Journal. Hays, KS: St. Joseph's Academy and Military College.

St. Joseph's College Bulletin. Hays, KS: St. Joseph's Academy and Military College.

Storm, Marlyn. *The First Hundred Years*. Hays, KS: 1973.

Time. "Husbandry: Heat & Wheat." July 21, 1930.

Wooster, Lyman Dwight. *A History of Fort Hays State College, 1902–1961*. Hays, KS: 1961.

www.arcadiapublishing.com

Discover books about the town where you grew up, the cities where your friends and families live, the town where your parents met, or even that retirement spot you've been dreaming about. Our Web site provides history lovers with exclusive deals, advanced notification about new titles, e-mail alerts of author events, and much more.

Find Your Place in History.